POSTCARD HISTORY SERIES

Troup County
IN VINTAGE POSTCARDS

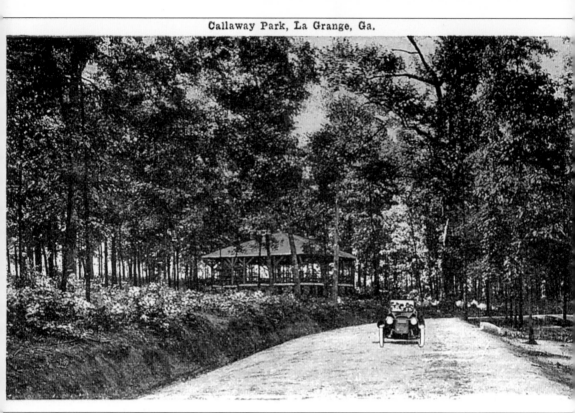

Callaway Park, La Grange, Ga.

This car and its passengers are touring LaGrange in the early 20th century. (S.H. Kress & Co.)

POSTCARD HISTORY SERIES

Troup County
IN VINTAGE POSTCARDS

Troup County Historical Society

ARCADIA

Published by Arcadia Publishing,
an imprint of Tempus Publishing, Inc.
2 Cumberland Street
Charleston, SC 29401

Printed in Great Britain.

Library of Congress Catalog Card Number: 2002107390

For all general information contact Arcadia Publishing at:
Telephone 843-853-2070
Fax 843-853-0044
E-Mail sales@arcadiapublishing.com

For customer service and orders:
Toll-Free 1-888-313-2665

Visit us on the internet at http://www.arcadiapublishing.com

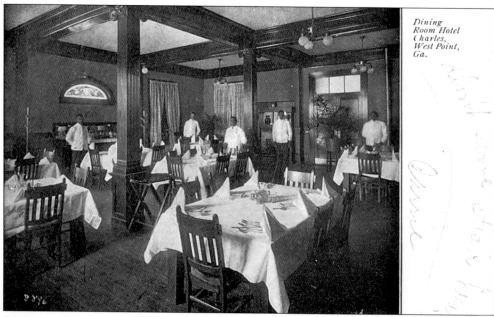

Dining in West Point could be an elegant event at the Hotel Charles, even if they did not serve steaks as someone noted on the card. The card is postmarked 1909 but actually dates before 1907 since the back of the card has room only for the address. (Courtesy of Gary Doster.)

CONTENTS

ACKNOWLEDGMENTS

The Troup County Historical Society is indebted to a variety of people for helping make this book a reality. Ken Thomas began urging us to do a postcard book for LaGrange and Troup County while he worked on his own *Columbus, Georgia in Vintage Postcards* in 2001. Ken generously lent us postcards for the book and sent photocopies and faxes on several occasions. He polled the Postcard Club of Georgia, and they recommended the postcard that appears on the cover of this volume. In addition to capturing a thriving Main Street in LaGrange, the card shows the Troup County Archives building on the left and McLellan's 5 & 10 Store on the right where we hope to develop "Museum on Main," a museum devoted to the history of Troup County, West Georgia, and East Alabama. We are delighted that they recommended this postcard for the cover and wholeheartedly agree with the decision.

Postcards have long been popular among collectors, and this book benefited from several such collections. Alice Hand Callaway gave the archives an extensive collection of postcards—including many of LaGrange—in the mid-1980s. Chris Joseph shared his cards, as did Diana Thomas and her father Marvin Irwin. Gary Doster, author of several Georgia volumes in *The Postcard History Series*, generously shared cards from his collection. A new collector and LaGrange native, Charles Hays contributed cards from his collection. In West Point, Stephen Johnson generously shared his collection as did Dorothy Young. The Cobb Archives let us borrow several postcards. Chris Cleaveland shared his cards and expertise; over one-fourth of the cards included in this volume are his.

Others who offered their expertise and time include Barry Jackson, Jim Biagi, Miriam Ann Syler, Jane Strain, Jean Ennis, Gloria Darden, and William Davidson.

Finally, and most importantly, we need to thank the following who gave their time and energy in authoring this volume. These four Troup Countians chose postcards, studied layouts, wrote captions, and sought out elusive bits of information. We appreciate their efforts and we appreciate their families, who had several late dinners during the spring and early summer of 2002. They are

Kaye Lanning Minchew
Forrest Clark Johnson III
Chris Cleaveland
Stephen Johnson

We hope you enjoy their efforts!

Anita "Bit" Taylor
President, Troup County Historical Society
136 Main Street
P.O. Box 1051
LaGrange, GA 30241

June 15, 2002

INTRODUCTION

Postcards became a new and a popular form of communication in the early 1900s. Color postcards, often printed in Germany, became popular in the first decade of the century. Providing a unique way to share images of a town and send a greeting, the cards cost only 1¢ to be mailed and made staying in touch with friends and loved ones easier. In the days before widespread telephone use, postcards allowed courtships to blossom, vacationers to say hello to those back home, and children of all ages a chance to give their parents a brief update on their activities. In some communities, postcard clubs even formed. Local residents would send postcards to club members across the country and expect to get images of another town or site in the mail in a few days. Color postcards quickly became a great way to show off one's hometown. With postcards, local residents could brag about new textile mills, colleges, hotels, railroad depots, or local gardens and parks. Later cards often showed how busy and vibrant the town's Main Street was. They also beckoned new businesses and industries to a community.

Another kind of card that became popular in the early 20th century involved having photographs of families, homes, or local events printed on postcard stock. These "real photo" cards then appeared in family photo albums or showed up in a relative's mail.

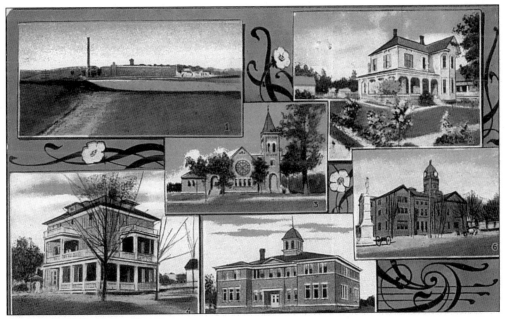

A postcard from LaGrange, Georgia.

A postcard from Hogansville, Georgia.

Troup County has many examples of the various types of postcards. The vast majority of the cards feature scenes from the three cities: LaGrange, West Point, and Hogansville, which are spotlighted with greeting cards here. These three cities were the centers of activity for most of the county's residents. Even farm families anxiously anticipated periodic trips into town to get supplies, see friends, and much more.

In the late 20th century, postcards became popular collector's items. Some collectors search every antique store or rare bookshop, always looking for a card missing from their collections. Other collectors hang on to postcards sent on special occasions by beloved family members. Some collections are more specific, focusing on railroad buildings or a particular town.

While the majority of the cards in this volume are from Troup County, cards from Chambers County, Alabama, provide an exception to this rule. Textile mills in Lanett and what became the city of Valley in 1980 have long been associated with the city of West Point. Some homes and stores located across the state line in Alabama, which had an impact on the economy and social life of Troup County residents, are also included.

A postcard from West Point, Georgia.

One
STREET SCENES

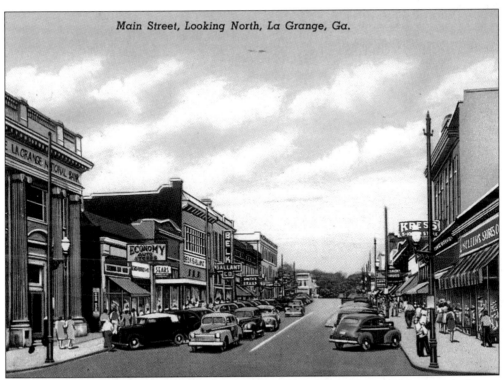

Main Street, Looking North, La Grange, Ga.

Main Street in LaGrange was a busy spot in the mid-to-late 1940s. This card shows a typical scene from the post–World War II era. Note the two-way traffic on Main Street (it has carried one-way traffic heading north since the 1960s.) McLellan's, Kress's, and Economy Auto Store were the Wal-Mart and Kmart of their day. (Curteich.)

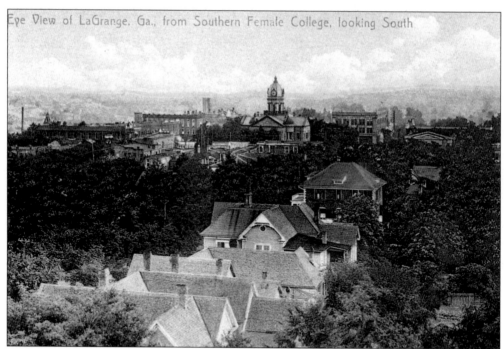

This view was probably taken from one of the towers at Southern Female College. Located on Church Street between Smith and Battle Streets, the Baptist school occupied the site on the north end of town from 1868 until closing in 1918. The domed tower of the Troup County Courthouse, built in 1904, rises above other downtown buildings. (Made in Germany.)

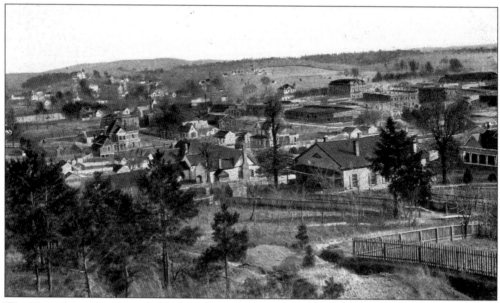

West Point is seen in the early 1900s looking southeast from the top of Fort Tyler hill, west of the river. The Griggs house (right, foreground), built in 1858, still stands with cannonball holes in the wall created during the Battle of West Point on April 16, 1865. Downtown commercial buildings can be seen beyond the house. (T.J. Mattox, Montgomery. Made in Germany.)

Looking east toward the courthouse about 1930, Calumet Mill and mill village are visible in the upper right. The three-story brick structure in the lower left is the Terrace Hotel, which stood on Broad Street from 1925 until 1955. A number of familiar downtown structures are visible, including First Baptist Church. (E.C. Kropp, Milwaukee.)

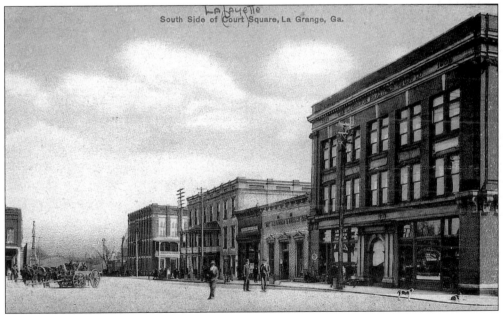

South Side of Court Square, La Grange, Ga.

The LaGrange Banking and Trust building stood on the south side of the Square from 1906 until 1994 when a disastrous fire demolished the structure. The Park Hotel on the corner still had its two-story verandah, as did the Truitt Opera house further down on Main Street. (Newvochrome. Printed in Germany.)

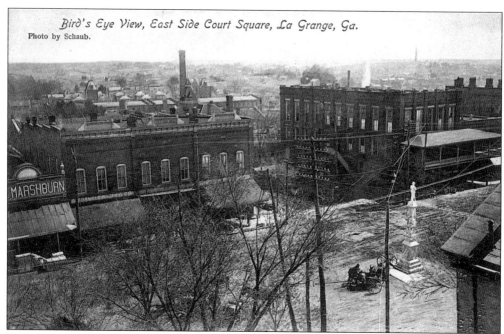

MARSHBURN

Taken from the roof of the 1904 courthouse, this photograph looks southeast toward Main Street. East Court Square and Marshburn's Store, with its rounded parapet, appear in the upper left. The Confederate Statue stood in its original location facing south to greet people coming from the railroad depot. Reporter Publishing Company of LaGrange, which produced the town's main newspaper for many years, published the card. (Photo by Schaub. Reporter Publishing Co.)

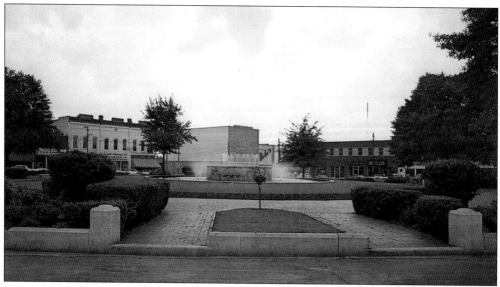

This postcard shows basically the same view as the one above, but the photographer took this one from the ground. Erected in 1948, the fountain stood where the courthouse had been located until burning in 1936. (The statue of LaFayette was placed in the center of the fountain in 1976.) The Truitt Opera House has been plastered over with a sign for King Dollar Store. (Colorama, Columbus, Georgia.)

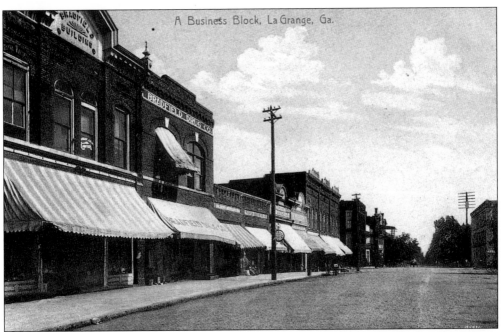

Horace King, or his sons John and George, constructed every building in this view of East Court Square. Born a slave, King became a master covered bridge builder. The family moved to LaGrange in about 1872 and constructed bridges, buildings, and homes. King died in 1885 but his sons continued the family building tradition in Troup County for another generation. John was a Sunday School superintendent and trustee of Warren Temple Church for more than 50 years. (Made in Germany.)

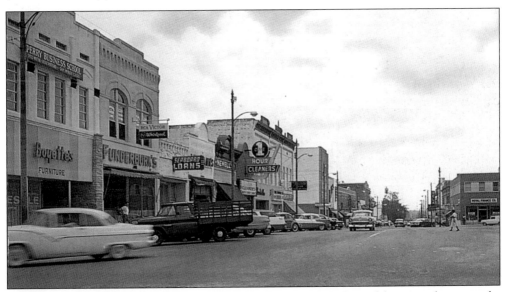

The same view of East Court Square seen above is shown *c.* 1960. One of the many changes to the facades of the stores is the addition of a third rounded parapet. The Park Hotel, on the far right in the top postcard, burned in 1953. The Mallory-Hutchinson building, with its modern architectural styling, replaced the hotel. (Colorama, Columbus, Georgia.)

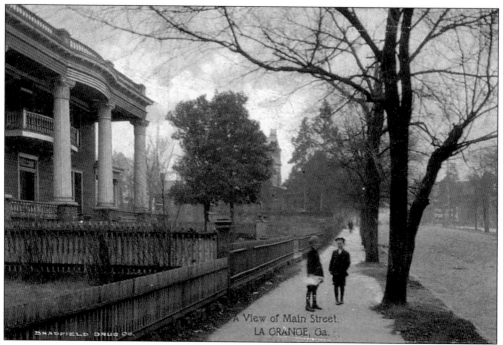

Looking north up Main Street, this postcard shows the Will Cleaveland house, which stood one and one-half blocks south of the Square. The tower visible in the center is the cupola of the James G. Truitt house, located on the corner of Main and Broome Streets. (Bradfield Drug Store.)

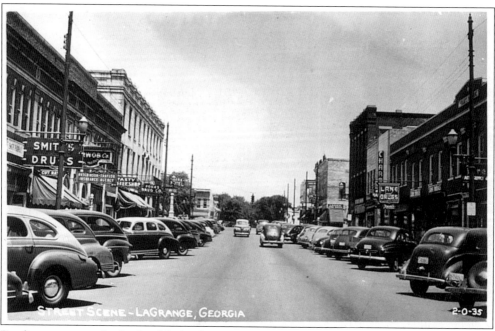

Bustling commerce in the first block of Main Street south of the Square is clearly evident in the mid-20th century. The three-story building in the center of the card on the left is the Park Hotel.

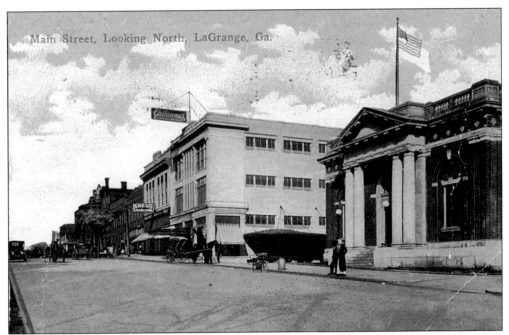

The then-new 1913 U.S. Post Office stands on the right. Callaway's Department Store is seen just beyond, across Broome Street. The store stood from 1913 until 1923, when it was destroyed by fire. Fuller E. Callaway Sr. replaced the building with a two-story structure—designed by Atlanta architects Ivey and Crook—which housed McLellan's Department Store for almost four decades. Built in 1913, Kress's 5 & 10 Store is next door.

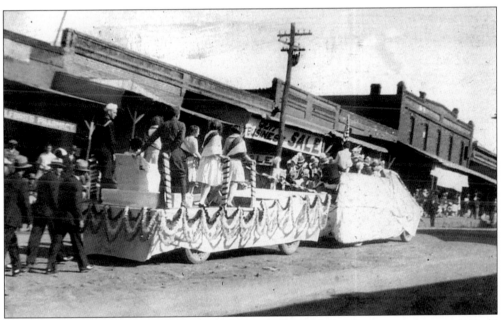

Main Street in Hogansville was the scene of this parade, which may have commemorated World War I. A sailor and a soldier rode on the back of the float. A popular type of postcard in the early 20th century involved printing photos on postcard stock.

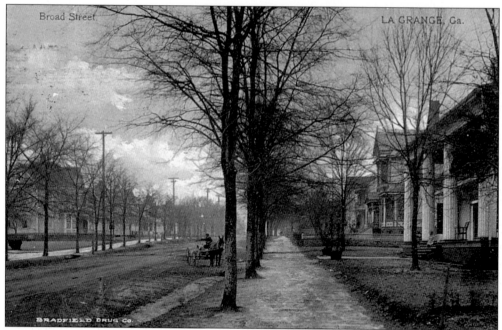

Bradfield Drug Company published a series of LaGrange postcards in sepia tone showing many downtown scenes. Mailed in 1910, this card looks east from Broad Street toward Court Square. The Culberson-Atkinson house is in the foreground on the right, next door to the Leslie Dallis house (which became In Clover Restaurant and later Culpepper-ReMax Realty.) Next, in the center, is the Edwards-Milam house. Note the packed dirt sidewalks.

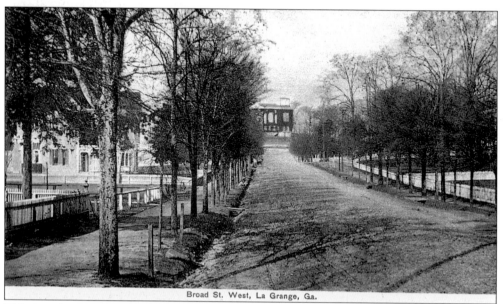

This Broad Street shot looks from downtown toward Dobbs Auditorium at LaGrange College. The card was printed in Germany for American News Company of New York. The Victorian house in the center left is the Moon House, constructed about 1900. (American News Co., New York. Made in Germany.)

16

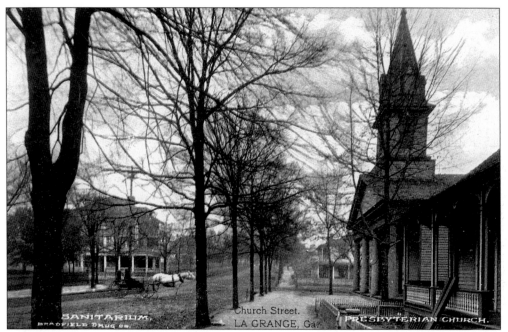

The card above, *c*. 1910, shows on the right a cottage built by Mrs. A.V. Heard, who lived next door. Next is the First Presbyterian Church with its steeple built by John King. Beyond and across West Haralson Street is a home built in the 1880s. A horse and carriage rest on the opposite corner, near the Slack Sanitarium. (Bradfield Drug Co..)

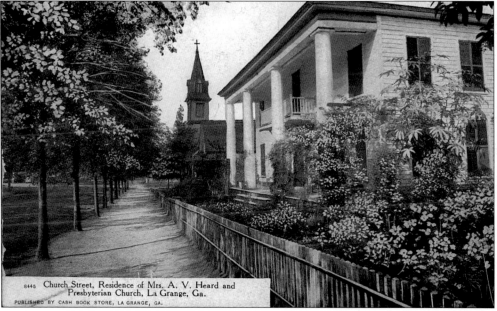

A similar scene shows the home of Dr. and Mrs. George B. Heard just south of First Presbyterian Church. Her beautiful formal gardens were among the finest in town. This house later served as the home of LaGrange Woman's Club. They razed the house to build LaGrange Memorial Library on the site. (Cash Book Store, LaGrange. Printed by Curteich.)

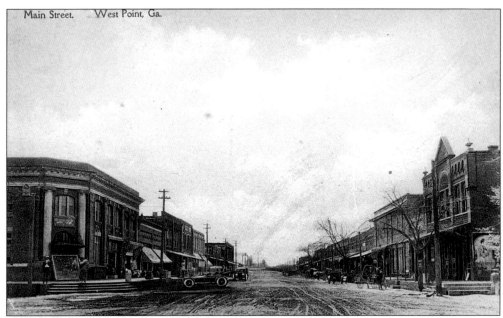

The main street of West Point, formerly Gilmer Street, is Third Avenue today. This view, taken at the intersection of Montgomery Street (now West Eighth Street), looks toward the Alabama line. The Bank of West Point building is seen on the left and the Heyman, Merz & Co. towers on the right. Note the raised sidewalks built above street level following the flood of 1886. The card was postmarked in 1918. (Albertype Co., Brooklyn.)

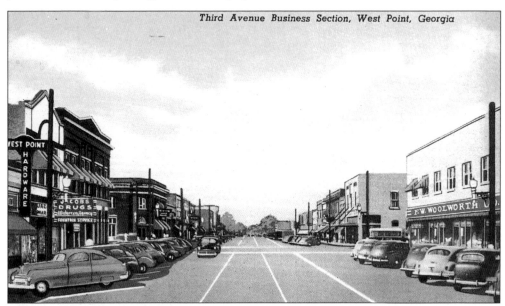

Third Avenue Business Section, West Point, Georgia

Compare this card with the one above. This one shows the same scene 40 years later, but the photographer stood about a half-block northeast of the previous view. The Bank of West Point remains essentially unchanged. The Heyman-Merz building was remodeled, as were most of West Point's downtown buildings, following the cyclone of March 1920. This card dates from the 1940s. (Curteich.)

18

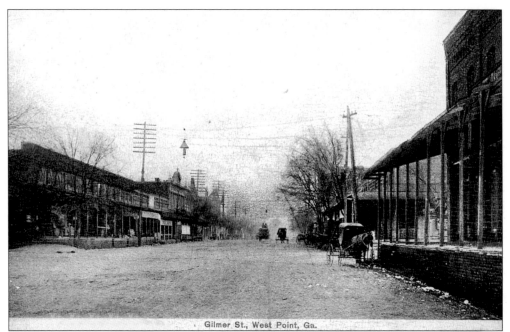

Gilmer St., West Point, Ga.

This early postcard shows West Point's main street, known then as Gilmer Street and probably named for George R. Gilmer, who served as governor of Georgia (1829–1831 and 1837–1839). The two images on this page depict the street from a point opposite that of the two cards on page 18. Note the electric lines and the street light. Wagons and buggies were still common forms of transportation when this card was made. (American News Co., New York. Printed in Germany.)

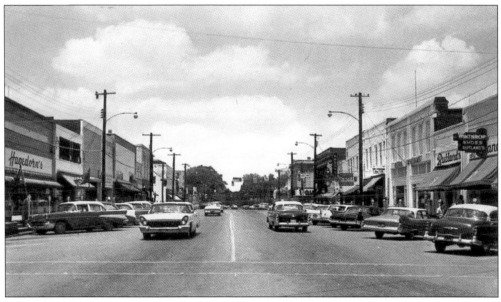

The same scene as above, but pictured 50 years later, shows dramatic changes in storefronts and transportation. The automobiles date this photograph to about 1960. Traffic was heavier then on this block of Third Avenue when U.S. Highway 29 ran to the intersection of West Eighth Street. (Colorama, Columbus, Georgia.)

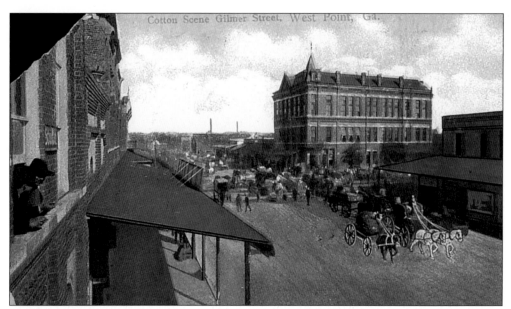

Stephenson Brothers photographers took this photograph of West Point's main street from their studios on the second floor of the Eady-Baker building. The three-story W.C. & L. Lanier Building, constructed in 1884 on the corner of Gilmer and Montgomery Streets, stands in the background. The image has been retouched, eliminating utility lines, smokestacks, and trees. The horses and wagons in the right foreground have also been retouched. (T.J. Mattox, Montgomery.)

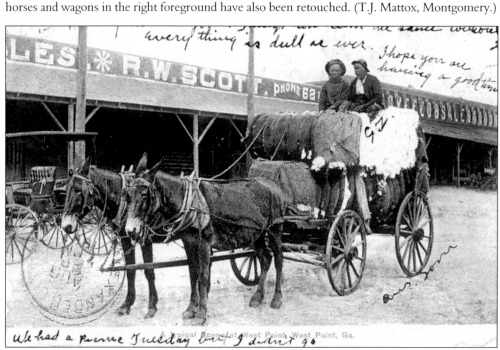

Cotton wagons pulled by mules were still a typical sight in West Point in the early 1900s. The livery stable owned by T.L. Smith and R.W. Scott appears in the background and is thought to have been located near the Alabama state line on either Gilmer or Jackson Street. (American News Co., New York. Printed in Germany.)

20

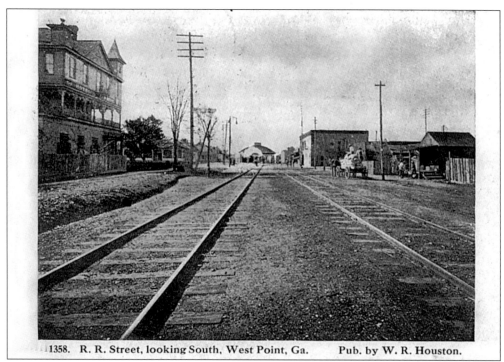

1358. R. R. Street, looking South, West Point, Ga. Pub. by W. R. Houston.

Railroad Street, later Second Avenue, was divided by the Atlanta and West Point Railroad, as seen here looking southwest toward the car shed. The Hotel Virent, shown at left, stood on the northeast corner where Montgomery Street (now West Eighth Street) crossed the rails. (Pre-1907 card, mailed in May 1910.)

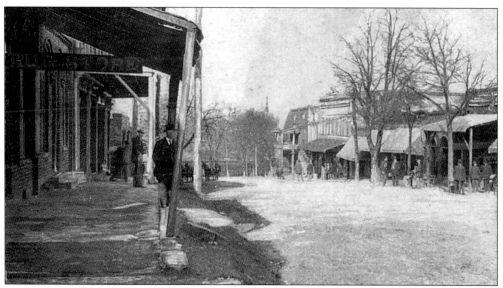

Main Street, Hogansville, just after the turn of the 20th century, reveals a variety of store awnings and dirt streets. The Grand Hotel, built about 1890, can be seen just past the drug store in the lower left. As was customary in those days, merchants stood out front or played checkers while waiting for customers. (McGown-Silsbee Litho Co., New York.)

21

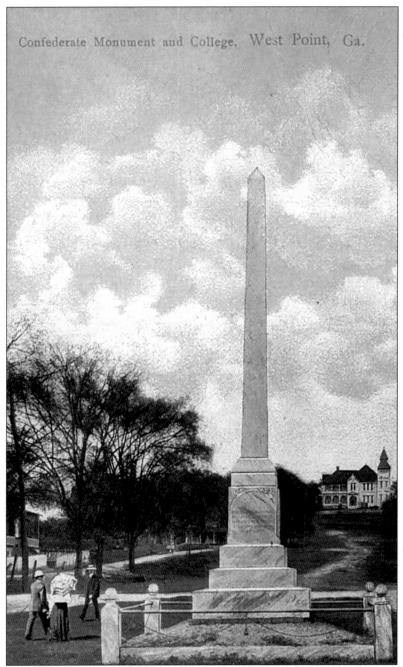

Confederate Monument and College, West Point, Ga.

The Ellidge and Norman Company designed and built the Confederate Monument in West Point. The United Daughters of the Confederacy and the Ladies Memorial Association raised the funds. Frank L. Stanton, who was appointed Georgia's first poet laureate in 1925 by Gov. Clifford Walker, wrote the inscription on the monument, and Lucian Lamar Knight, noted Georgia historian, spoke at the unveiling on May 23, 1901. The original location, seen here, was the intersection of Ferry (East Eighth) and Richmond (Avenue C) Streets. The public school is shown in the background. (T.J. Mattox, Montgomery.)

Two
TRAVELING AND TRANSPORTATION

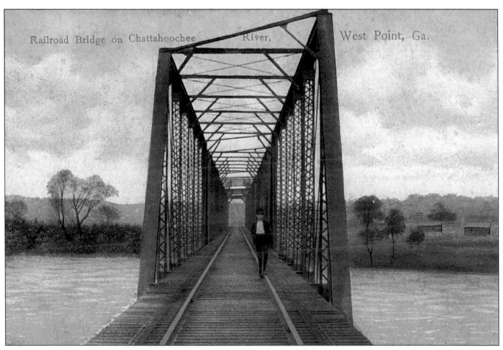

Railroad Bridge on Chattahoochee River, West Point, Ga.

This view of the railroad bridge looks northeast toward the east bank of the river and LaGrange. The bridge appears slanted because it crosses the river at an angle. Built in 1892, this steel bridge replaced a wooden bridge built in 1867-1868 after an earlier one was burned following the Battle of West Point in 1865. (T.J. Mattox, Montgomery. Made in Germany.)

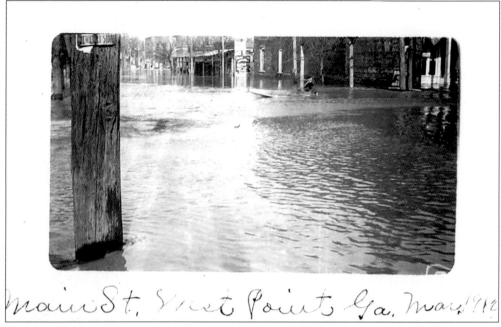

main St, West Point, Ga, May 1912

These cards show one of the many floods that periodically plagued West Point. Both are photographs printed on postcard stock after the March 1912 flood. The card is labeled "Main St." but so little of the buildings are visible that it is difficult to determine the exact location.

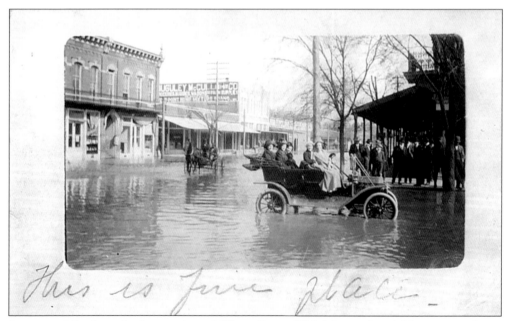

This is fine place

An automobile sits at the intersection of Gilmer Street (Third Avenue) and Montgomery Street (West Eighth Street), while onlookers stand next to the Lanier Building. Across the street are the Atkinson and Huguley-McCulloh Buildings. This card shows that two kinds of currents were at work: water currents and the then-current trend toward automobiles. Cars were quickly becoming the number one choice in local transportation—even among women drivers!

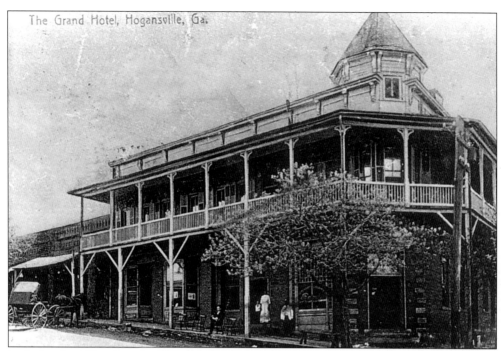

The Grand Hotel, Hogansville, Ga.

In the heyday of hotels such as the Grand in Hogansville, principal patrons were business travelers who arrived on the railroad. As early as 1894, the hotel had a woman serving as proprietress. The Grand had shops, sleeping rooms, and a dining room. Crowned with a cupola, the building had a two-story verandah that wrapped around the corner. Still a part of commercial life, the Grand remains a Hogansville landmark.

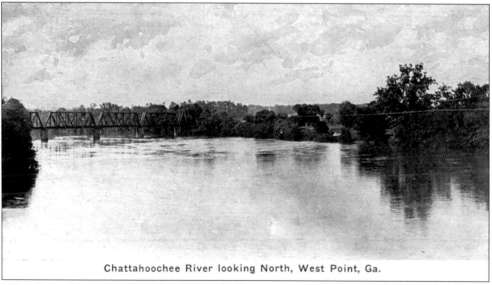

Chattahoochee River looking North, West Point, Ga.

Taken from the automobile and pedestrian bridge that connected Ferry and Montgomery Streets (now East and West Eighth Streets), this postcard shows the Atlanta and West Point (A&WP) Railroad, which crossed the river above downtown and continued down Railroad Street, paralleling both Gilmer Street and the river. (Auburn Greeting Card Co., Auburn, Indiana.)

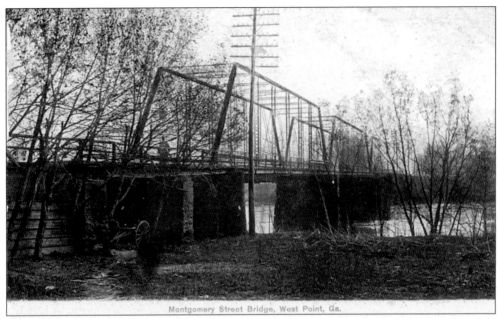

Montgomery Street Bridge, West Point, Ga.

Automobiles, wagons, and pedestrians all used this bridge, which was built following a flood in 1886. The bridge connected Ferry Street (later College Street and now East Eighth Street) with Montgomery Street (now West Eighth Street), one block north of an earlier bridge. It was destroyed in the flood of December 1919 and replaced by a similar steel bridge in the same location. (American News Co., New York. Made in Germany.)

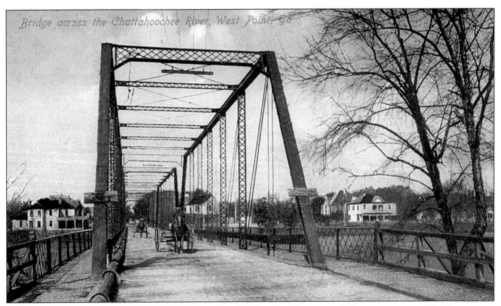

Bridge across the Chattahoochee River, West Point, Ga.

This postcard shows another view of the 1886 bridge looking west. The two-story white house on left was the Lord Boarding House. The two-story white house on the right was the Shaefer home, where West Point ladies made a flag for Fort Tyler in 1865. Both houses have since been demolished. Note the water line running along the left side of the bridge. The card was postmarked in 1915. (W.R. Houston, West Point. Made in Germany.)

26

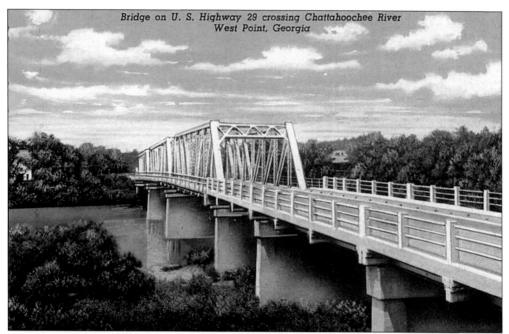

Bridge on U. S. Highway 29 crossing Chattahoochee River
West Point, Georgia

Built in 1920, this steel bridge replaced the 1886 bridge destroyed in a 1919 flood. It was built by Virginia Foundry and Iron Works of Roanoke, Virginia, and it was demolished in 1977 when U.S. 29 was rerouted and a new bridge connected East Tenth Street and West Ninth Street. The card dates from the 1940s and appears to be looking west toward downtown. (Curteich.)

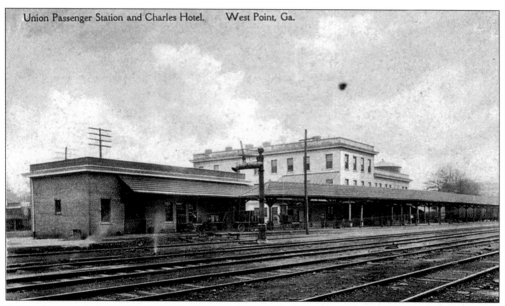

Union Passenger Station and Charles Hotel. West Point, Ga.

Located east of the Alabama line, the passenger depot was built after the old car shed was demolished in 1909. The building at the left was the Railway Express Agency office and warehouse, and it also served as the ticket office after the hotel was demolished in 1964. Passenger rail service was discontinued in 1980 and the building was demolished a few years later. (Albertype Co., Brooklyn.)

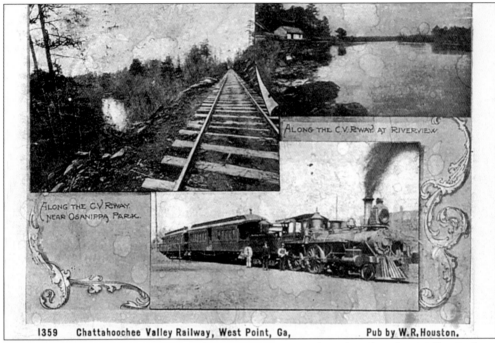

1359 Chattahoochee Valley Railway, West Point, Ga, Pub by W.R.Houston.

Built in 1895 for West Point Manufacturing Company, the Chattahoochee Valley Railway connected West Point to Langdale, Alabama, and connected Lanett and Langdale Mills with West Point. The railway reached to River View, Alabama, in 1897 and to Bleecker, Alabama, in 1916. This composite card, postmarked in 1907, shows three scenes along the railroad. (W.R. Houston.)

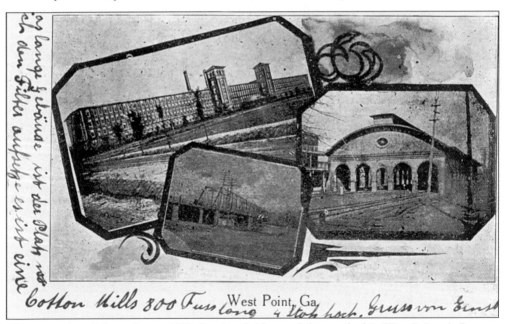

This unusual card shows Lanett Mill, the river bridge, and the car shed in West Point. A German visitor evidently wrote the inscription. He was impressed by "cotton mills 800 feet long and 4 stories high." Perhaps he was a Jewish merchant or related to one of the merchants of West Point.

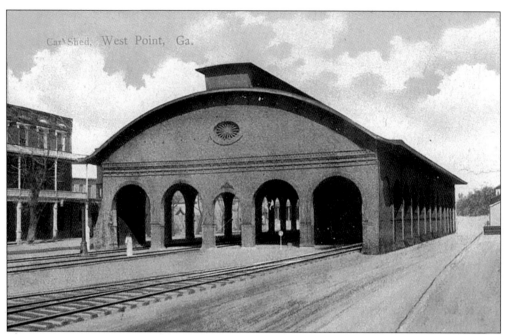

The car shed was used by both the A&WP Railroad and the Montgomery and West Point Railroad of Alabama (Western Railway). Architect Daniel H. Crown designed the car shed, which was built in 1858. On the left is the Hotel Langley, formerly the Chattahoochee House and later the Charles Hotel. (T.J. Mattox, Montgomery. Made in Germany.)

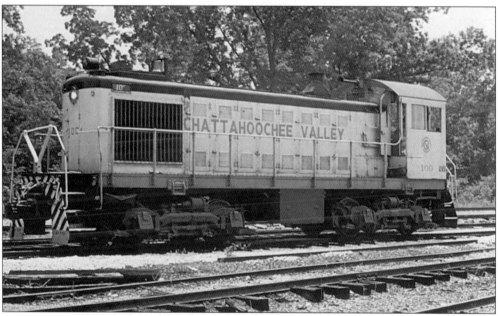

This card is a 1960s color photograph of a diesel engine used by the Chattahoochee Valley Railway in its later years. The railroad was abandoned in 1992 and the track removed in 1993. A part of the old C.V. Railroad bed in the city of Valley, Alabama, has been made into a hiking and biking trail. (Mary Jayne's Railroad Specialties. Postcard by Mary Jayne Rowe. Used with permission.)

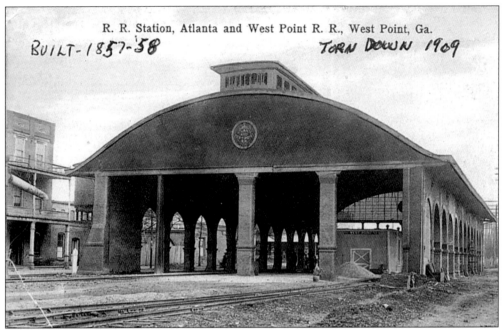

R. R. Station, Atlanta and West Point R. R., West Point, Ga.

BUILT-1857-'58 TORN DOWN 1909

A later view of the car shed in West Point shows extensive remodeling done to accommodate larger engines and rail cars. Arches were "squared up" to keep the structure serviceable. Because Alabama and Georgia had different gauge tracks until 1886, all passengers and freight traveling between Atlanta and Montgomery before that date had transferred from one train to another at West Point. (City Drug Co., West Point. Made in Germany.)

Built in September 1865, this A&WP depot replaced the one burned by Col. Oscar H. LaGrange and Union troops in April of that year. This view depicts the south end of the depot. The back of the postcard has the same wood-grain finish as the front and an undivided area allowing space only for an address. (Tom Jones, Publisher, Cincinnati, Ohio, for Reporter Publishing Co. of LaGrange.)

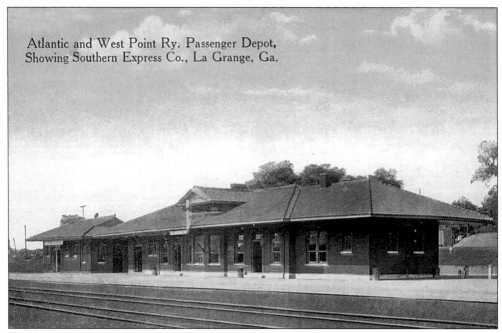

Atlantic and West Point Ry. Passenger Depot,
Showing Southern Express Co., La Grange, Ga.

Looking from the southwest, the 1911 A&WP depot is shown here with the Southern Express Company Shipping Office on the southern end. The depot served passengers for several decades. Despite the efforts of members of the Troup County Historical Society and others, the depot was torn down in 1993. (S.H. Kress & Co.)

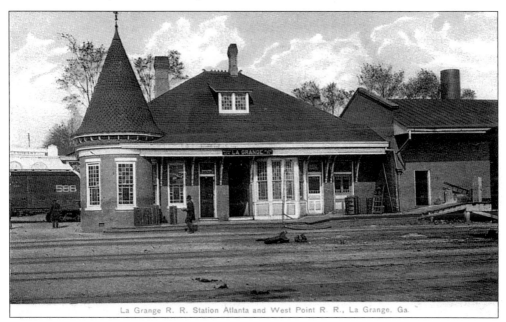

La Grange R. R. Station Atlanta and West Point R. R., La Grange, Ga.

The eastern side of the 1865 A&WP depot shows the freight warehouse that was added on the north end. There were separate waiting rooms for men and women and maid service to assist travelers. In 1882, maids for ladies and children were added to the A&WP trains as well. (American News Co., New York. Made in Germany.)

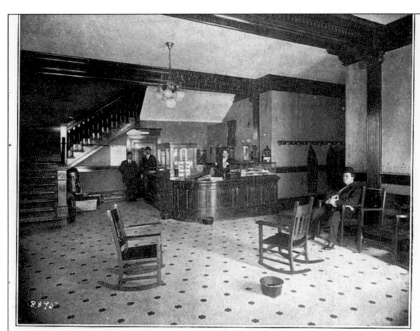

The A&WP Railroad remodeled the Hotel Langley in the early 1900s. The structure had been built as the Chattahoochee House before 1860 and renamed the Charles Hotel, honoring Charles Wickersham, president of the railroad. The remodeling included the addition of Neo-Classic trim and molding. This lobby scene is a far cry from today's upscale hotels, with its tile floor, sparse furniture, and spittoon! The card is postmarked 1909.

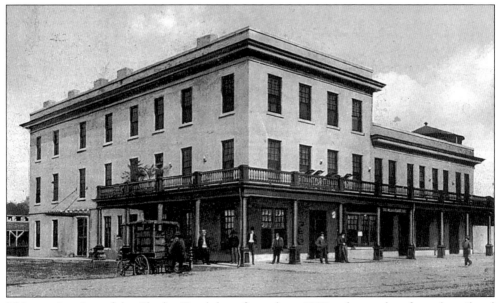

This exterior view of the Charles Hotel dates from about 1915 and was taken from the railroad looking toward the front of the hotel, which faced what is now West Seventh Street. The opening of the Charles Hotel was celebrated with a gala ball attended by much of West Point society. This card is postmarked 1922. (W.R. Houston, West Point. Printed in Germany.)

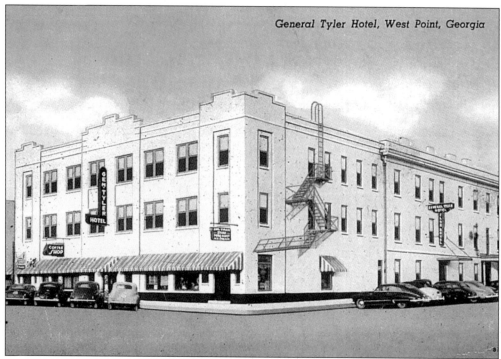

In 1938, proprietors enlarged the Charles Hotel by building a three-story wing facing Third Avenue (old Gilmer Street). It was renamed the General Tyler Hotel in honor of Brig. Gen. Robert C. Tyler, killed in the Battle of West Point in 1865. The General Tyler ballroom served as a venue for a variety of social functions until demolition of the hotel in 1964. The card below is postmarked 1948. (Above: courtesy of Ken Thomas; below: Dexter Press, Pearl River, New York.)

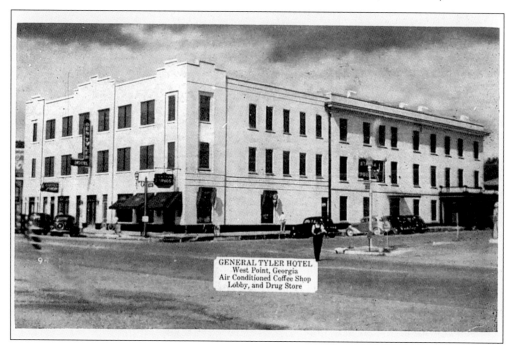

GENERAL TYLER HOTEL
West Point, Georgia
Air Conditioned Coffee Shop
Lobby, and Drug Store

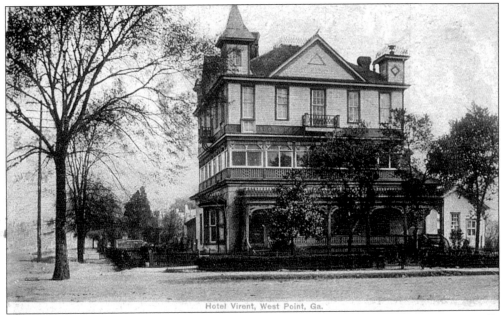

Hotel Virent, West Point, Ga.

Located at the northwest corner of West Eighth Street and Second Avenue, this hotel was originally the home of Lafayette Lanier, West Point banker and industrialist. W.L. Williams bought the house, added a third story, and renamed it the Hotel Virent. The name comes from Latin meaning "to flourish" or "to become green." The card is postmarked 1907; the building was demolished in 1932. (American News Co., New York. Printed in Germany.)

This card, postmarked 1939, shows the Hotel Colonial, LaGrange's finest of the era. Built in 1922, the hotel was an addition to the home of its owners, Anna, Ethel, and Lois Young. The last hotel to operate in downtown in the 20th century, the Colonial offered rooms and fine dining. Franklin D. Roosevelt spoke here in 1929 while serving as governor of New York. The hotel later became an office building. (E.C. Kropp, Milwaukee.)

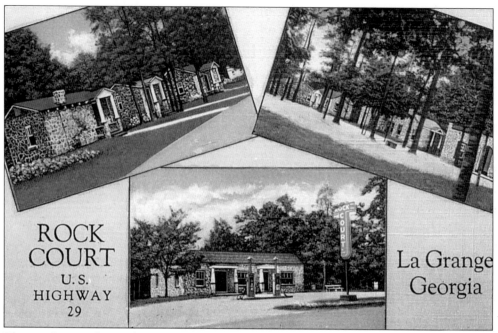

ROCK COURT
U.S. HIGHWAY 29

La Grange Georgia

The growing popularity of automobiles and leisure travel gave rise to tourist courts, frequently seen along the roadside. The one above was on West Point Road, southwest of LaGrange. The one below, postmarked 1953, was on New Franklin Road just north of town. Both places also sold gasoline to tourists. (Above: Curteich; below: Tichnor Brothers, Boston.)

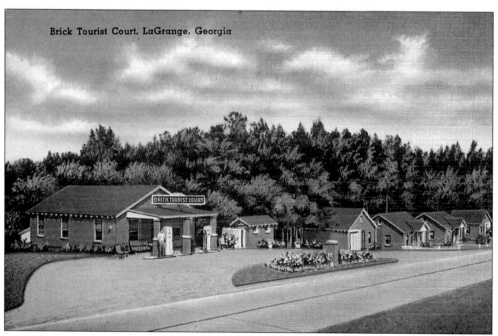

Brick Tourist Court, LaGrange, Georgia

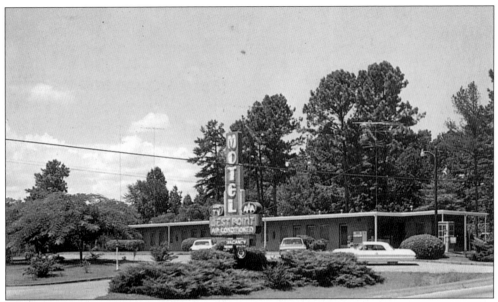

The West Point Motel was built in the early 1950s on U.S. Highway 29, just north of the city limits, when this highway was carrying an increasing amount of tourist traffic. Still in operation, the motel mainly caters to fishermen and visitors to nearby West Point Lake. Interstate 85 diverted much of the road's formerly heavy traffic. (Courtesy of Charles Hays. Printed by Richard J. Douglas, Pell City, AL.)

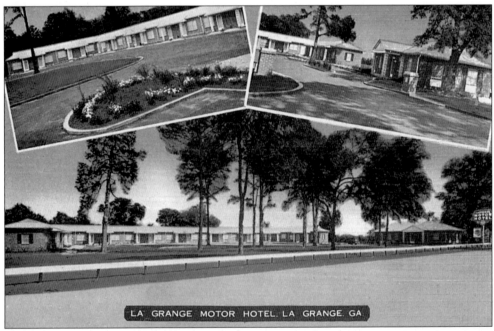

The automobile brought a change in hotel accommodations. The "motel"—a step up from tourists courts—was a word coined by combining motorists and hotel. LaGrange Motor Hotel sat one-half block north of Shadowlawn Cemetery on New Franklin Road near its intersection with Commerce Avenue. (Courtesy of Charles Hays. E.B. Thomas, Cambridge, Massachusetts.)

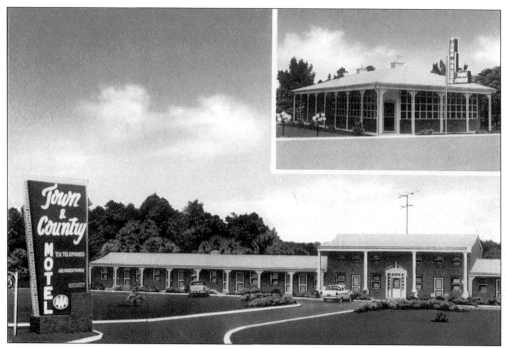

These two cards show the Town & Country Motel and its adjacent restaurant. Located on U.S. 27 two miles north of the Square, the motel proudly advertised air conditioning on its front sign. When constructed in 1956, the Town & Country was considered to be well north of town. The card below shows automobiles from the mid-1960s. (Above: U.O. Colson Co., Paris, Illinois; below: printed by Richard J. Douglas, Pell City, Alabama.)

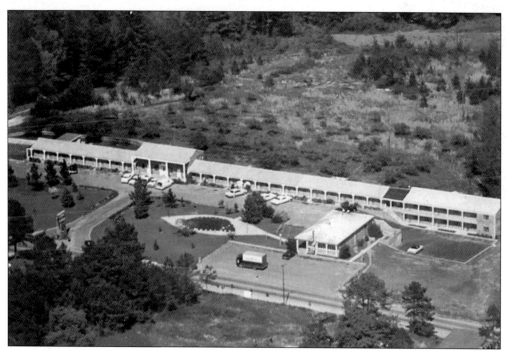

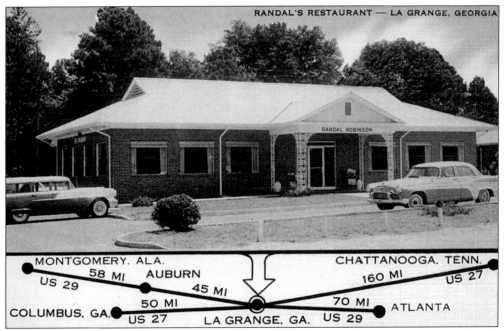

MONTGOMERY. ALA.
58 MI AUBURN
US 29 45 MI
50 MI
COLUMBUS, GA. US 27 LA GRANGE, GA. US 29

CHATTANOOGA. TENN.
160 MI US 27
70 MI ATLANTA

U.S. 27 and U.S. 29 were main transportation arteries that crossed in LaGrange when Randal Robinson built his restaurant on the corner of New Franklin Road and Commerce Avenue, north of the LaGrange Motor Hotel. Popular with tourists, the restaurant also hosted many local business leaders for breakfast. The cars date from the mid-1950s. (E.B. Thomas, Hampstead, New Hampshire.)

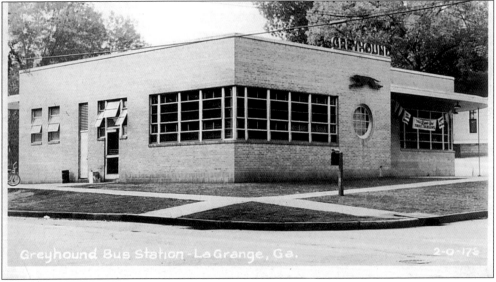

In the days before interstates, bus stations typically operated in downtowns. Located on Church Street at West Haralson Street, the Greyhound bus terminal stood one block north of the Square. This Art-Moderne structure, built by Greyhound in 1948, replaced the old Dunson Hospital building that had once occupied the site. Gay and Joseph Accountants have preserved the building as offices since 1986.

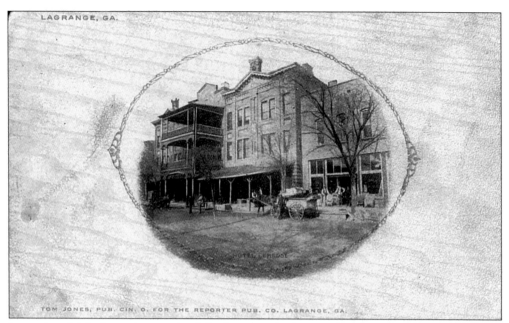

Located on Main Street just south of the Square in LaGrange, the Elmrose was built in 1889 by John Andrews and was known as the Andrews Hotel. In 1906, the name was changed to Elmrose, paying homage to LaGrange's nickname, "the City of Elms and Roses." (Tom Jones, Publisher, Cincinnati, Ohio, for Reporter Publishing Co. of LaGrange.)

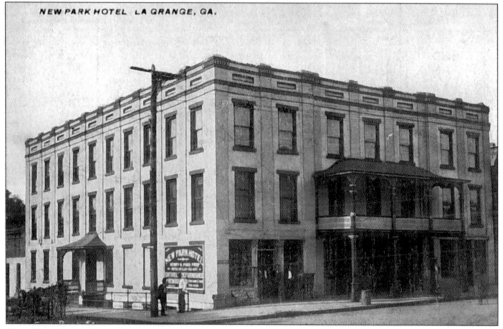

The "New" Park Hotel had just undergone a refurbishing before this postcard was made. The building dated from the 1840s and was one of the few buildings on the Square that did not burn in 1865. The hotel hosted many celebrities over the years, including actor Edwin Booth, brother of Lincoln's assassin John Wilkes Booth. The hotel burned in 1951. (Cash Book Store.)

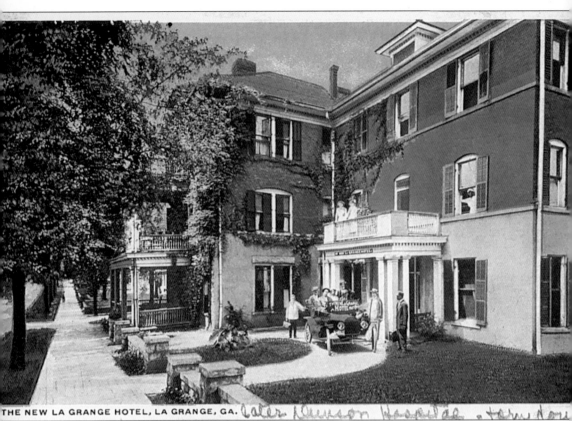

THE NEW LA GRANGE HOTEL, LA GRANGE, GA.

This postcard of the old Slack Sanitarium was made after the building became a hotel. Doctors still housed patients there occasionally and locals dined there. In 1916, the building became Dunson Hospital, the town's first public medical facility. On the back of the postcard is an ad that reads "the New LaGrange Hotel, Headquarters for Traveling Men, American Plan. Rates $2.50 per day and up. Clean Linen, Sanitary Surroundings. Wholesome meals and Polite Attention. J.W. Andrews, Proprietor." (Curt Teich Postcards & Co., Chicago.)

Three
PUBLIC PLACES

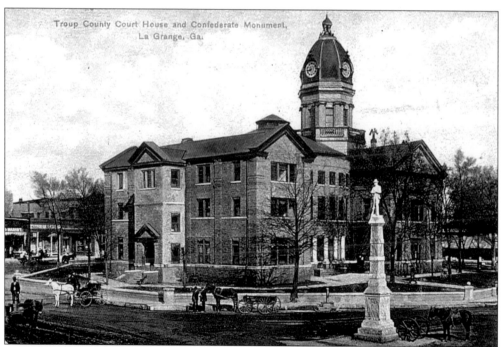

Built in 1904, the Troup County Courthouse served the public until 1936. With the building of the new courthouse on Ridley Avenue, the Square was made an octagon with a stone wall enclosing a park. Note the cannon in the foreground next to the Confederate monument that proved handy as a hitching post. (American News Co., New York. Made in Germany.)

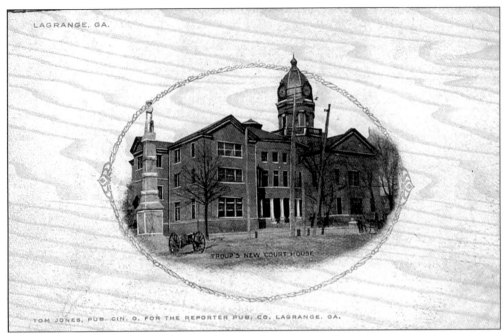

TROUP'S NEW COURT HOUSE

TOM JONES, PUB. CIN. O. FOR THE REPORTER PUB. CO. LAGRANGE. GA.

Two similar views of the courthouse were made 30 years apart. The top view was taken shortly before builders finished adding the stone facing to the facade. C.C. Thotherow and Company of Birmingham built the courthouse that was designed by A.J. Bryan, architect, of New Orleans. (Tom Jones, Publisher, Cincinnati, Ohio, for Reporter Publishing Co. of LaGrange.)

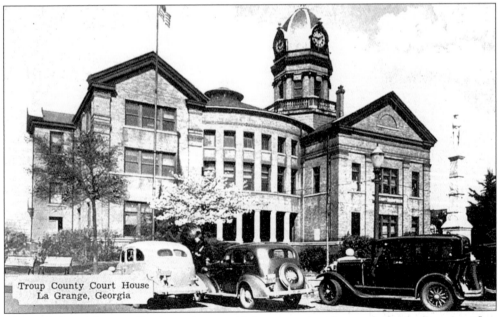

Troup County Court House
La Grange, Georgia

This card shows the completed courthouse with its stone trim plus a pole for the American flag. The soldiers' monument has been moved to face the east. The cars parked around the courthouse date from 1935–1936. When the courthouse burned on November 5, 1936, diligent local citizens saved most of the county's records. (Dexter Press, Pearl River, New York.)

42

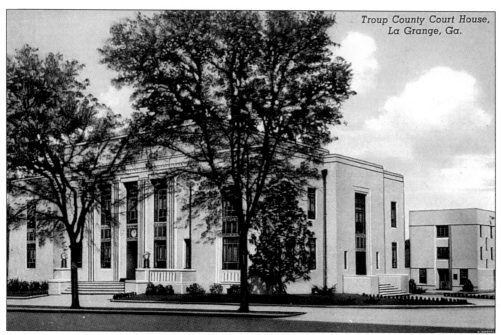

Troup County Court House, La Grange, Ga.

Two views of the "new" courthouse, built in 1939, are shown here. William J.J. Chase designed the courthouse, one of the few Art Deco buildings in the county. Public opinion helped save the main building in 2001 when officials, with support from the voters, decided that county government and the court system needed a larger, more modern facility. (Above: Curteich.)

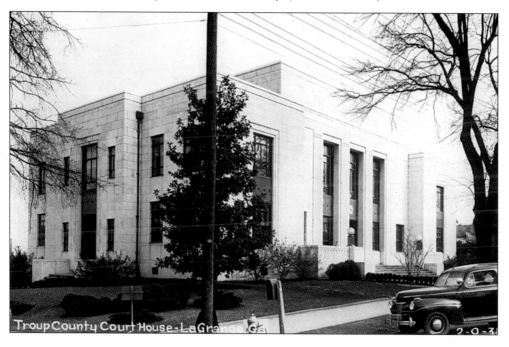

Troup County Court House—LaGrange, Ga.

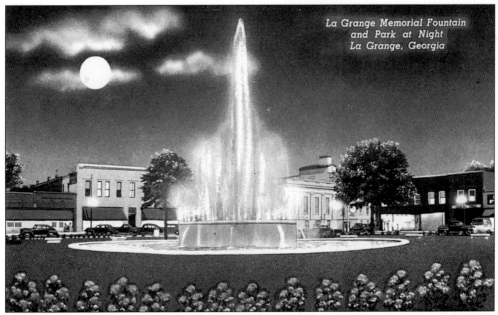

When the new courthouse was built off the Square in 1939, the area became a public park. Troup County gave the property to LaGrange for use by its citizens. The city added the fountain in 1948. Lights that periodically changed color drew people each evening to watch as the water and its sprays changed height and seemed to dance. A statue of LaFayette was placed in the fountain in 1976. (Curteich.)

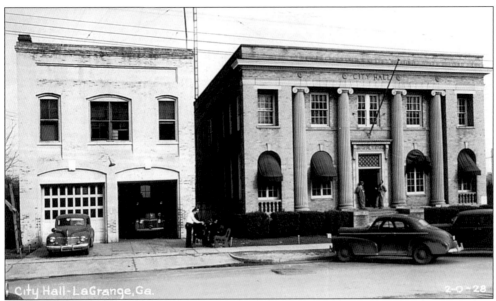

This view of the LaGrange City Hall showed the original city fire station. Awnings provided ornamentation and protection from the summer heat. This fire station served as the city's only firehouse for 60 years; a new station was built at the south end of Main Street in 1977-1978. Firemen appear to be playing checkers in the grassy area between the two buildings. Cars appear to range from 1941 to 1943 models.

44

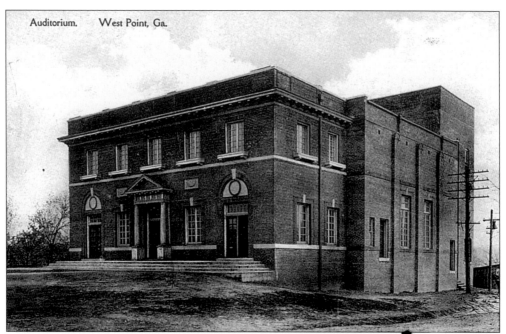

Built on Montgomery Street in 1915, the West Point City Auditorium cost $17,550 to construct. Pike Brothers Lumber Company of LaGrange built it. Beginning with the showing of *The Birth of a Nation* on May 17, 1916, the auditorium served as the town's movie theater. Traveling shows, school dramatic performances, and graduations took place here. The card is postmarked 1920; flood damage in 1961 led to its demolition. (Albertype Co., Brooklyn.)

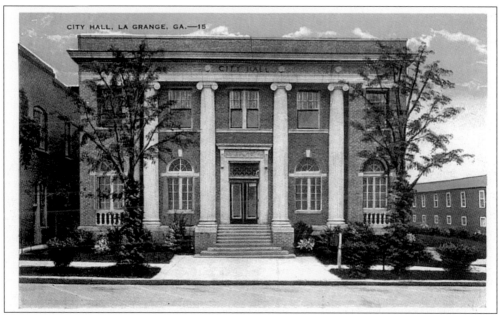

This card, postmarked 1935, provides a close-up view of the Neo-Classical details of the 1926 building. In the background on the right are the Cleaveland and Roper stables, which were razed to make way for the 1939 courthouse. (E.C. Kropp, Milwaukee.)

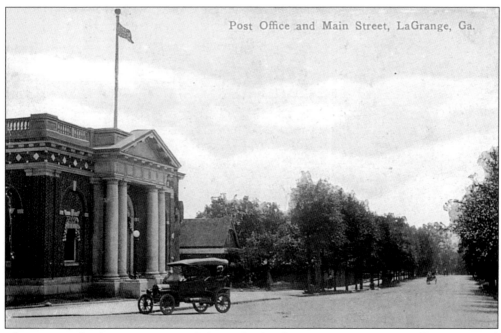

Post Office and Main Street, LaGrange, Ga.

These postcards show two views of the Federal-style 1913 LaGrange post office. A central pediment supported by massive Tuscan columns graces the entranceway. The arched windows and the balustrade across the top add visual interest. This building served until a new post office was built on Church Street in 1962. The building served as home for the LaGrange Board of Education for almost three decades.

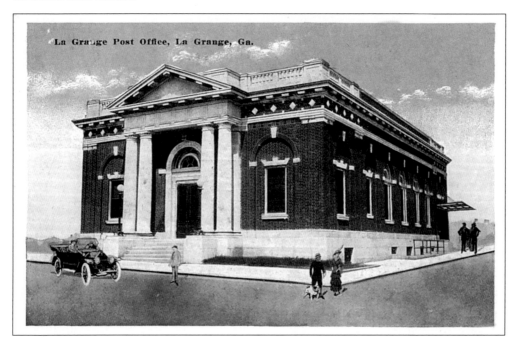

La Grange Post Office, La Grange, Ga.

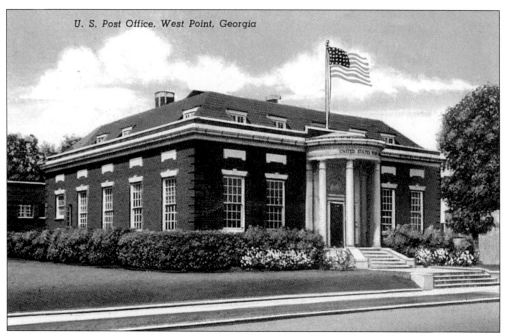

U. S. Post Office, West Point, Georgia

These cards both feature the Federal-style West Point post office. This 1932 building is one of the few post offices of that era still in use as a post office. Its rotunda-shaped portico and Temple of the Winds columns are central features. A stone eagle greets patrons as they enter. It is located at the corner of Fourth Avenue and West Eighth Street. (Above: Curteich; below: Dexter Press, Pearl River, New York.)

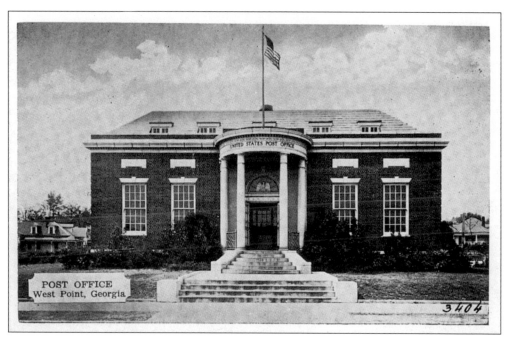

POST OFFICE
West Point, Georgia

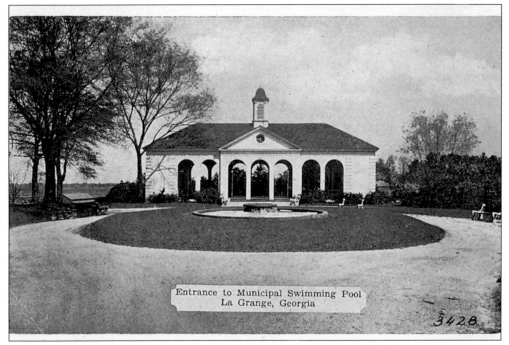

Entrance to Municipal Swimming Pool
La Grange, Georgia

3428

Used by the public since 1935 and seen on a card postmarked 1940, the LaGrange City Pool was constructed with support from the Works Progress Administration of the United States government. The cards on this page and the top of the next page offer different views of the pavilion and pool. Atlanta architects Ivey and Crook designed the structure. (Above: Dexter Press, Pearl River, New York; below: Dexter Press, Buford, Georgia.)

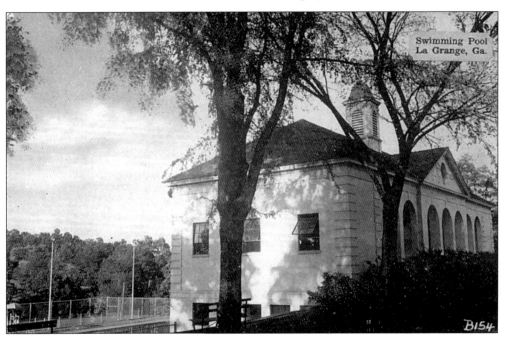

Swimming Pool
La Grange, Ga.

B154

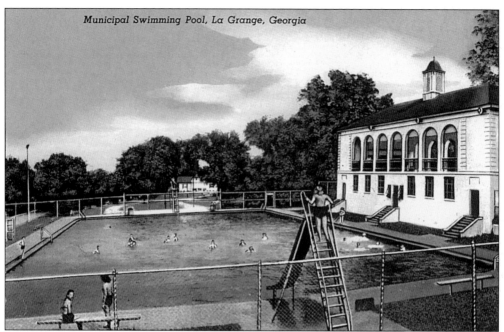

Municipal Swimming Pool, La Grange, Georgia

Before the city pool was built, many citizens cooled off during hot summers by swimming in what was originally a fishing pond where Springdale Drive and Gordon Circle now meet. Known as McLendon's Pond, the city park, shown below, sat on what had once been the grounds of Bellevue. (Above: Curteich; below: E.C. Kropp, Milwaukee.)

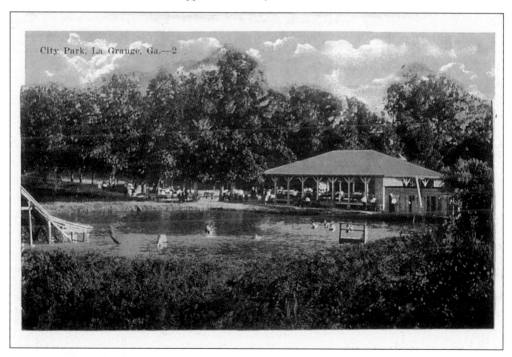

City Park, La Grange, Ga.—2

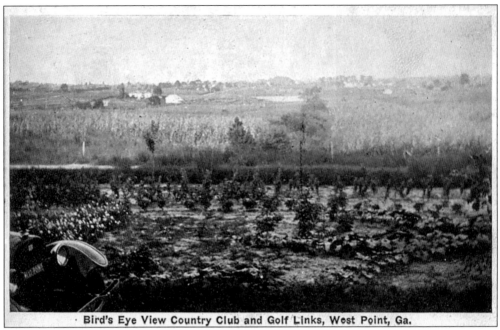

Bird's Eye View Country Club and Golf Links, West Point, Ga.

Riverside Country Club originated as a men's club on the west side of the Chattahoochee River, near downtown West Point. The club built a golf course west of Lanett, Alabama, in 1913 and moved to that location. The original Riverside Club is now the Magnolia Club, a guest house for visiting business dignitaries. (Courtesy of Ken Thomas.)

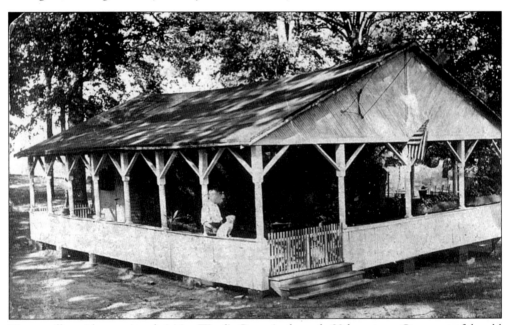

Hogansville residents enjoyed visiting Word's Grove in the early 20th century. Once part of the old Hogan plantation, this was a popular dance and picnic pavilion. Tables covered with food can be seen under the arbor-styled shed, perhaps for a Fourth of July celebration. The puppy sitting on the rail on the left appeared to pose for this card. (Owen's Photography, Hogansville.)

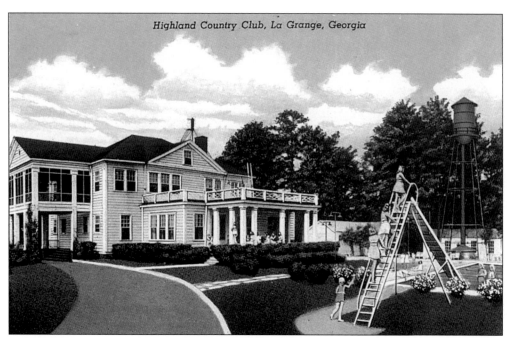

Highland Country Club, La Grange, Georgia

Pictured above is the Neel Reid-designed clubhouse of Highland Country Club and its original pool and playground. A newer structure replaced this clubhouse in 1967. (Curteich.)

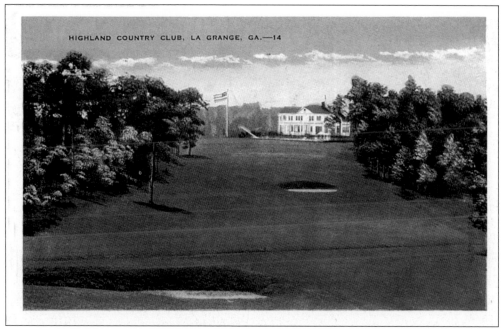

HIGHLAND COUNTRY CLUB, LA GRANGE, GA.—14

This card, postmarked 1942, shows another view of the clubhouse at Highland Country Club. The scene was taken from the original ninth-hole fairway. Famed golf course designer Donald Ross designed the course in 1922. With the addition of nine more holes in 1972, this became the eighteenth hole and fairway. (E.C. Kropp, Milwaukee.)

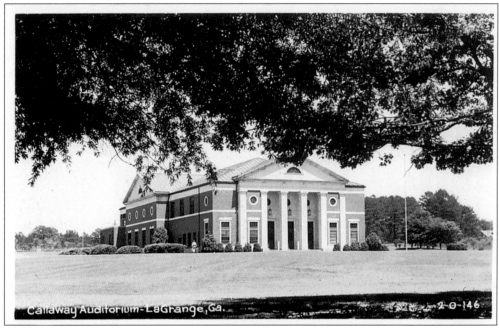

Callaway Auditorium was being constructed just before the U.S. entered World War II in December 1941, and the copper roof was finished just before such materials were needed for war support. Callaway Mills made the hall a memorial for employees who served in the Armed Forces. Given to LaGrange College in 1992, the structure continues to serve the college and the public as an auditorium.

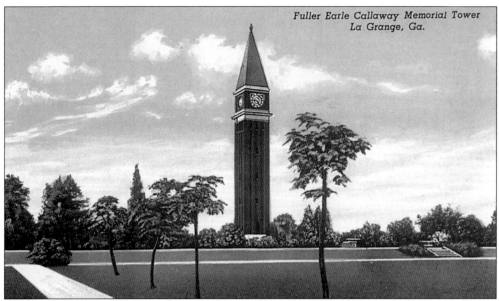

Fuller Earle Callaway Memorial Tower
La Grange, Ga.

Callaway Tower is a memorial to Fuller E. Callaway Sr. Built with contributions from Callaway Mill employees in 1929, a year following his death, the tower was designed by Ivey and Crook. Albert Lehmann did the clocks. It towers over southwest LaGrange in an expansive park. Annual wreath layings and picnics in memory of Callaway's death were held here. (Curteich.)

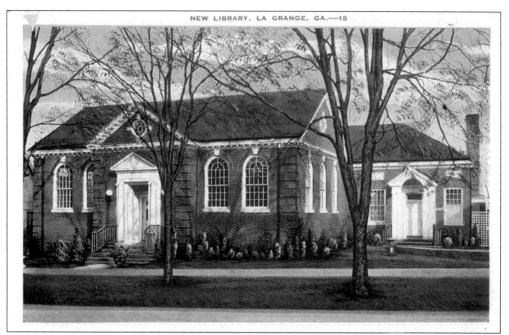

Dedicated to those who served in World War I, the LaGrange War Memorial Library and Woman's Club was built by the club on the site of an antebellum home that was once their meeting house. The Rotary Club of LaGrange helped raise most of the funds. A new facility was erected in 1975 on Broome Street. The Troup County Courts then used the building. (E.C. Kropp, Milwaukee.)

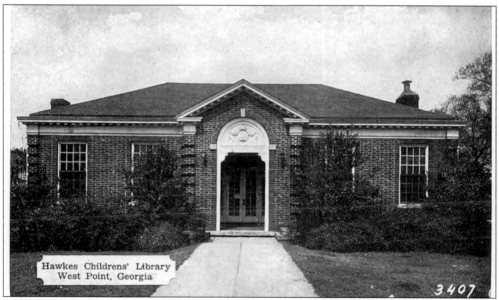

Hawkes Childrens' Library
West Point, Georgia

3407

Hawkes Children's Library was built in 1922 with a bequest of $7500 from Dr. A.K. Hawkes, an Atlanta optometrist. The City of West Point furnished the lot, opposite City Auditorium, next to the river bridge. The books of the Young Men's Library Association were donated, and West Point Woman's Club contributed $500 for new books. The building is now on the National Register of Historic Places. The card is postmarked 1947. (Dexter Press, Pearl River, New York.)

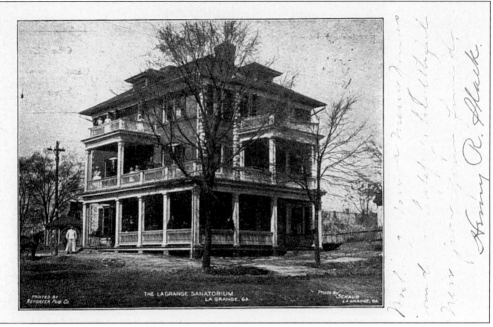

Dr. Henry R. Slack, who constructed this building in 1902 to house his private sanitarium, also sent and signed this card. The sanitarium stood on the northwest corner of Haralson and Church Streets. The building later became a hotel and then, in 1916, Dunson Hospital, the city's first public medical facility. The card is postmarked December 1905. (Photo by Schaub. Reporter Publishing Co.)

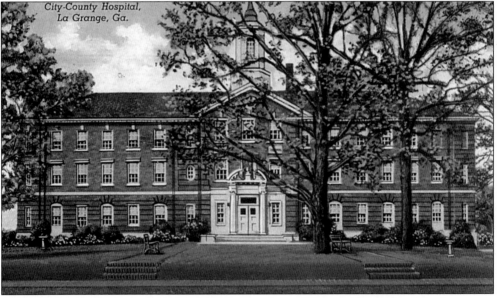

Finished in 1937, City-County Hospital was the successor of Dunson Hospital and the forerunner of West Georgia Medical Center. As its name implied, the hospital was a joint venture of LaGrange and Troup County. This building was razed in 1974 to make way for a new six-story building. (Curteich.)

54

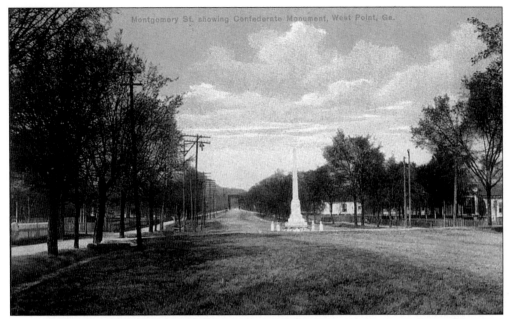

The name Montgomery Street on this card is a bit misleading because this section, east of the river, was actually called Ferry Street, and later College Street. This view was taken from the foot of College Hill, the site of the public school building. It shows the Confederate Monument in its original location, mid-street at the intersection of Richmond Street, now Avenue C, West Point. (Postmarked 1913. Newvochrome. Printed in Germany.)

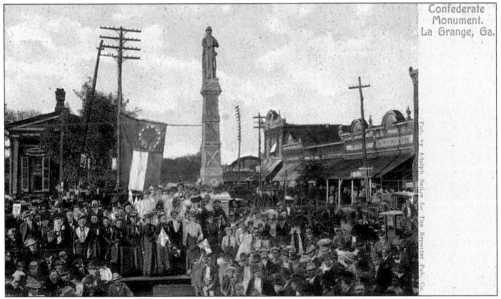

This 1907 postcard shows the 1902 dedication ceremony of LaGrange's memorial to Confederate soldiers. In the background on left is the building that housed the Clerk of Superior Court and the Ordinary (now Probate Court Judge). George and John King built the structure in 1886. The official Confederate flag appears to be hung improperly. (Courtesy of Gary Doster, A Selige Publishing Co., St. Louis, Missouri. Made in Germany.)

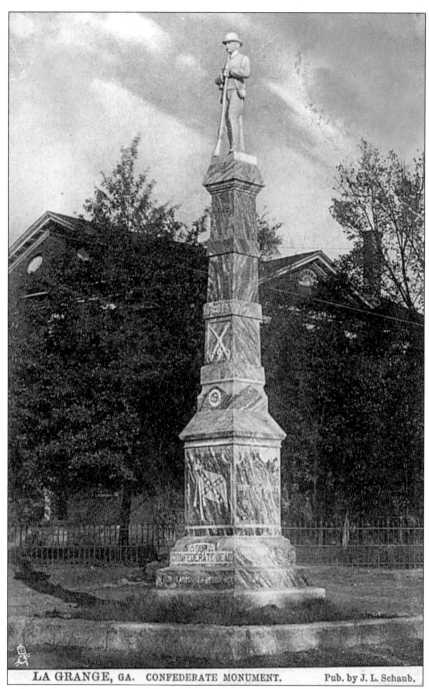

LA GRANGE, GA. CONFEDERATE MONUMENT. Pub. by J. L. Schaub.

"Lest we forget," a sentiment popular to any war memorial, applies equally to the old Troup County courthouse standing in the background and to the Confederate monument on which this is engraved. This courthouse was built in 1829 and served the county until 1904. The iron fence surrounding it now encircles the Confederate Cemetery on Miller Street. The statue, whose front base reads "In our hearts, they perish not," now faces north at the intersection of Morgan, Ridley, and New Franklin Streets. The card is postmarked 1908. (Raphael Tuck & Sons, Boston.)

Four
COMMERCE

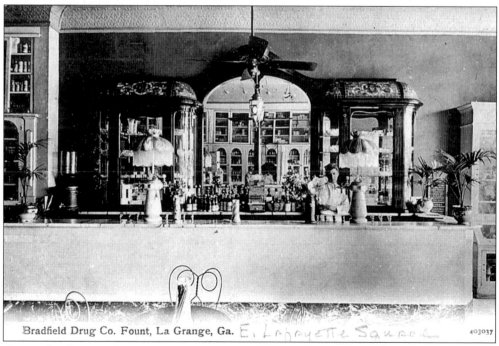

Bradfield Drug Co. Fount, La Grange, Ga. E, Lafayette Square 403037

Once a familiar site, but now long gone, the interior of this Victorian soda fountain has been preserved for prosperity with this blue-toned postcard. This card shows Bradfield Drug Store with its ornate architectural details. Located on East Court Square in LaGrange, the store printed and sold several Troup County postcards. Horace King constructed this building for James Loyd to house Dr. Thomas S. Bradfield's pharmacy in 1879. (Photographed and published by J.L. Schaub. Printed in Great Britain.)

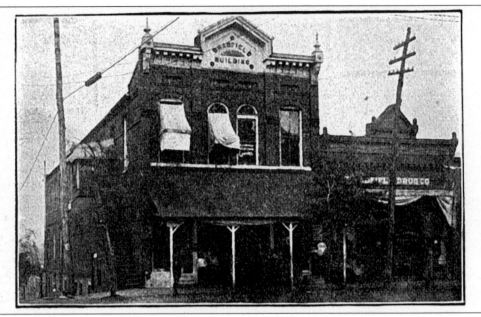

Edwin R. Bradfield had Horace King construct the end building at the northeast corner of the Square in 1877. It housed his department store, the first in LaGrange and the store where young Fuller Callaway learned the trade while working here from 1884 to 1888. The building on the right, seen in the previous card, was later enlarged to house Bradfield Drug Company. The Bradfield building boasted LaGrange's first plate glass windows.

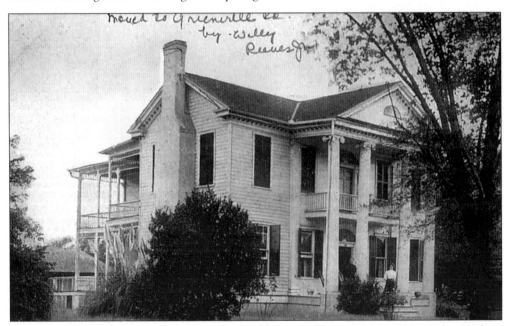

James Culberson built this Collin Rogers-designed house for his son-in-law, J.W. B. Edwards, later a militia general and veteran of the Mexican War. This was the longtime home of the Judson Milam family and became Maddox Funeral Home in March 1950. Wiley Reeves moved the home from Broad Street to save it from demolition, but Interstate 85 later claimed the building.

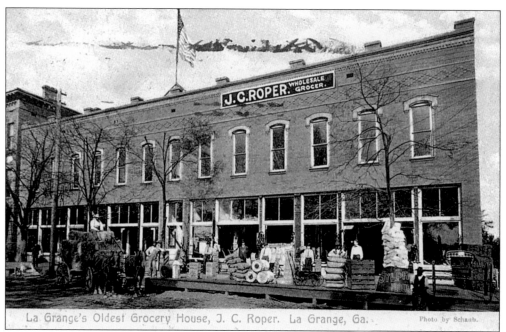

La Grange's Oldest Grocery House, J. C. Roper. La Grange, Ga.

Photo by Schaub.

Joel C. Roper operated his grocery concern in the building on Main Street shown in the postcard above, postmarked 1913. Shown below, the building on Morgan Street, built in 1907, housed Roper's cigar manufacturing business. It later became LaGrange Grocery Company, run by Frank G. Birdsong. The widening of Morgan Street in 1987 led to the razing of this warehouse. (Above: published by Adolph Selige for the Reporter Publishing Co. Photo by Schaub; below: Cash Book Store.)

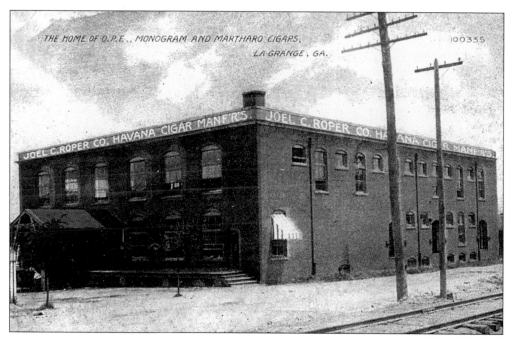

THE HOME OF O.P.E., MONOGRAM AND MARTHARO CIGARS,
LA GRANGE, GA.

100335

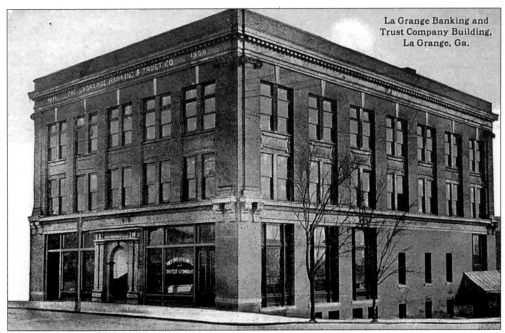

LaGrange Banking and Trust Company stood on the corner of Bull Street and the Square from 1906 until it burned in 1994. Over the years, the building also housed many offices, including E.D. Roberts Construction Company. In its last decades, the building was encased and hidden by a metal covering. LaFayette Plaza now occupies the site. (S.H. Kress & Co.)

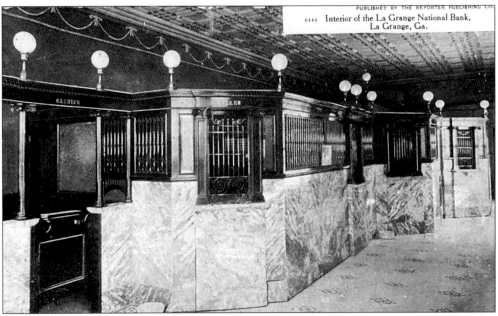

PUBLISHED BY THE REPORTER PUBLISHING CO.
8444 Interior of the La Grange National Bank,
La Grange, Ga.

The marble interior of LaGrange National Bank is shown when housed in the Loyd Building on the east side of the Square. Other attractive features included decorative swags and a pressed metal ceiling. The bank moved to a new building at the corner of Main and Broome Streets in 1917—that building now houses the Troup County Archives. (Curteich.)

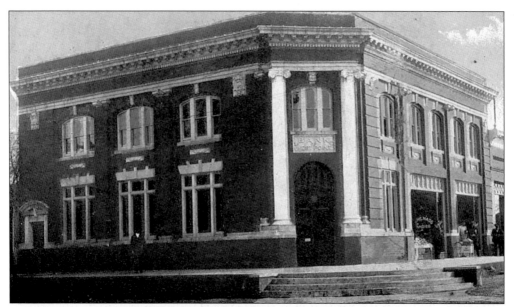

The Bank of West Point, organized in 1897, constructed the building shown above in 1907 on the southeast corner of Gilmer and Montgomery Streets, directly opposite the Lanier building. The bank liquidated in 1917, and the building housed a number of businesses and doctors' offices until restored by Leslie W. Scroggs, C.P.A., in 1989. (Photo by W.R. Houston.)

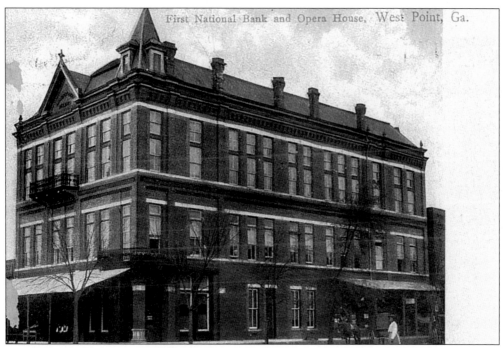

The W.C. and L. Lanier Building, West Point's tallest, was constructed in 1884 at the northeast corner of Gilmer and Montgomery Streets. First National Bank and West Point Manufacturing occupied the first two floors until about 1953. A 600-seat opera house filled the third floor until the 1920 cyclone destroyed the third floor. This card is postmarked 1915. (T.J. Mattox, Montgomery.)

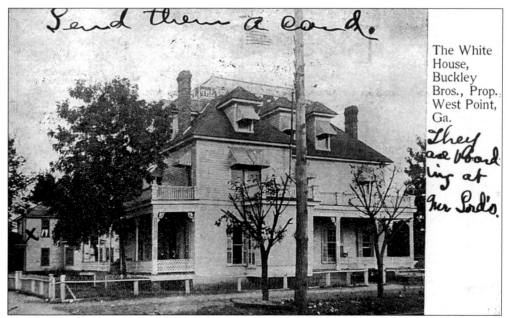

Send them a card.

The White House, Buckley Bros., Prop. West Point, Ga.

They are board ing at Mr Lord's.

The White House was a boarding house located on Montgomery Street (West Eighth Street) at the railroad. To the east was the Lord Boarding House, which stood until recently. The message on this 1909 card tells about a couple who ran away to get married and were boarding at the Lord House, next door and marked with an "X." (Courtesy of Gary Doster.)

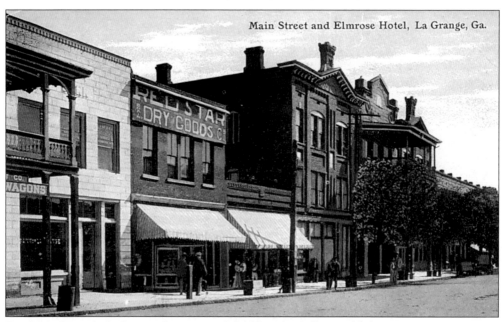

Main Street and Elmrose Hotel, La Grange, Ga.

East Main Street in LaGrange shows part of the Victorian balcony added in 1883 to Truitt Opera House by Lewis Gill, a black contractor. Next is the marble front Bank of LaGrange, the only facade still identifiable, followed by the Red Star Dry Goods Store, Hudson Hardware, and Elmrose Hotel. A 1931 fire destroyed much of this block. The card is postmarked 1912. (Courtesy of Gary Doster. Cash Book Store, LaGrange.)

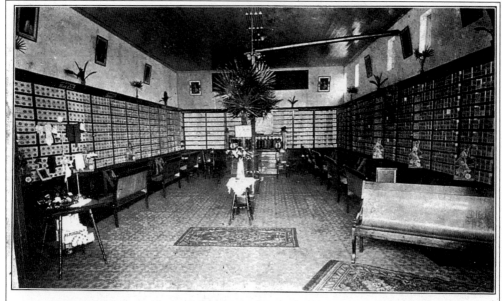

386. THE RED STAR SHOE STORE, LA GRANGE, GA. Schaub, Photo.
"STAR BRAND SHOES ARE BETTER."

The Red Star Shoe Store was, from the looks of this card, the latest in fashion and customer convenience when opened in 1908. Persian carpets and the pot-bellied stove in the back show that this is a vintage card. Run by E.W. Pinckard, the store was in the Thornton Building on West Court Square. (Photo by Schaub, T.N.Y.N. Co.)

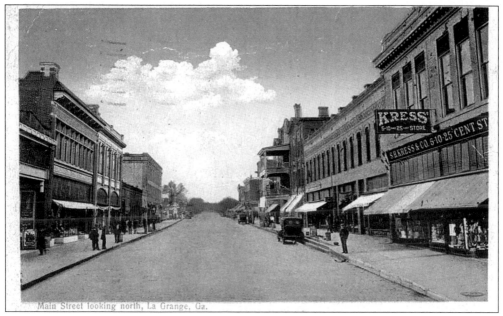

Main Street looking north, La Grange, Ga.

S.H. Kress and Company used the facade of their 1913 building and this scene of Main Street, postmarked 1923, to advertise to their customers. In this case, Nilco electric lamps cost 25 to 30¢ each. W.B. Sutherland served as manager in the 1920s and went on to serve as president of the company, based in New York. (S.H. Kress & Co.)

63

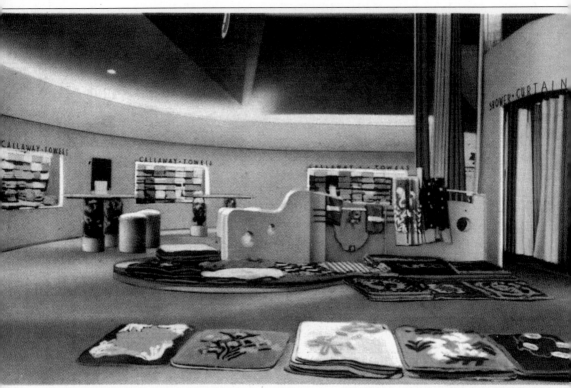

Interior View of CALLAWAY MILLS' TOWEL SALON on LINCOLN ROAD — MIAMI BEACH, FLA.

Troup County commercial interests extended beyond the county's borders, as this display of products by Callaway Mills in Miami Beach shows. The back of the card notes that the Callaway Mills Towel Salon displays "the latest styles of towels, rugs, draperies, and bathroom ensembles, all manufactured by the famous Callaway Mills in their Georgia plants." The salon was located on the fashionable Lincoln Road. Coincidentally, Callaway's Mill Store in LaGrange, operated by three generations of the Lester family, was on Lincoln Street for many years. (Curteich.)

64

Five

INDUSTRY

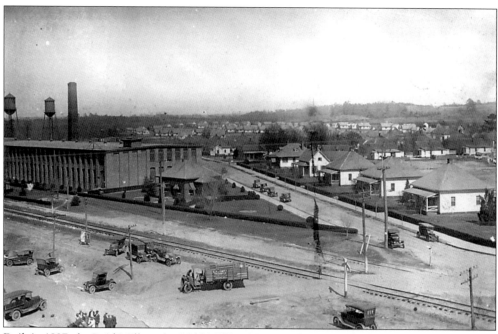

Built in 1897, the Reid Mill, or the "Old Mill" as Hogansville residents called it, is shown here with the mill village. Built as Hogansville Manufacturing Company and later owned by Callaway Mills, the plant has been torn down. This photo postcard appears to date from 1915–1916. Eight Model-T Fords are parked in the foreground. (Owens, Photo-Artist, Hogansville.)

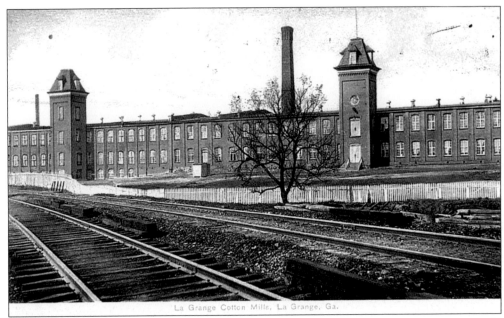

La Grange Cotton Mills, La Grange, Ga.

Constructed in 1888 by George and John King and designed by W.S. Cox, LaGrange Cotton Mills developed from an earlier cotton seed oil mill. The mill had several owners over time, including Callaway Mills, and several names, including Calumet. The plant was razed in 1986 to build St. Peter's Catholic Church after Milliken and Company donated the property to them. This card is postmarked 1908. (American News Co., New York. Made in Germany.)

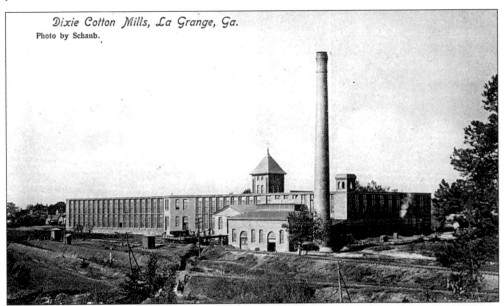

Dixie Cotton Mills, La Grange, Ga.
Photo by Schaub.

The oldest remaining mill in LaGrange, Dixie Cotton Mills opened in 1895. Among the investors were Fuller E. Callaway with his first textile venture. Purchased by West Point Manufacturing Company in 1933, the mill is now part of WestPoint Stevens. The community joined the company and Troup County Historical Society in celebrating the mill's 100th anniversary. (Photo by Schaub. Reporter Publishing Co. Made in Germany.)

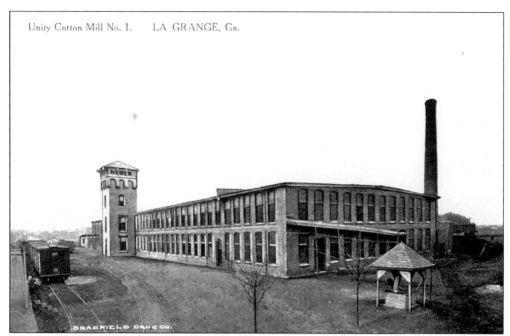

Unity Cotton Mill No. 1. LA GRANGE, Ga.

The Bradfield Drug card (above) and the S.H. Kress & Co. card below show Unity Cotton Mill, which was built in 1900 by Pike Brothers of LaGrange. The mill was the parent plant of what became Callaway Mills. Fuller Callaway spearheaded development of this plant. The mill was renamed Kex for the cotton duck material produced there.

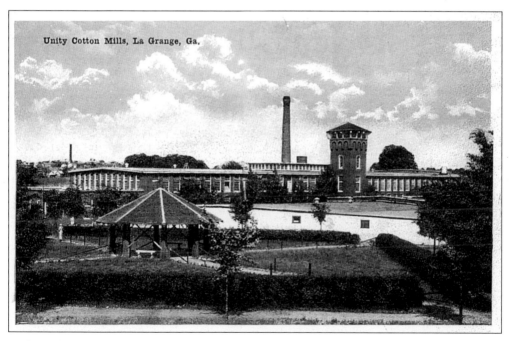

Unity Cotton Mills, La Grange, Ga.

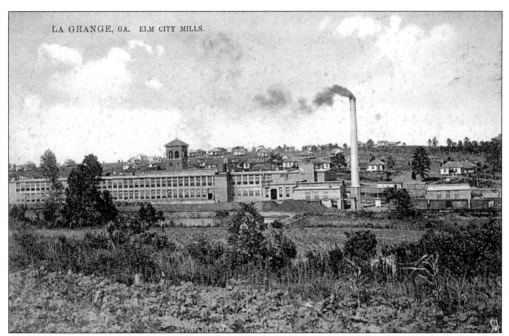

LA GRANGE, GA. ELM CITY MILLS.

Incorporated in 1905, Elm City Cotton Mill is located south of Callaway Stadium in southwest LaGrange. The name derived from LaGrange's nickname, "the City of Elms and Roses." This and other Callaway Mills were purchased by what is now Milliken and Company in 1968. A gazebo, not visible in these cards, and the Italianate tower are notable architectural features. (Above: Photo by J.L. Schaub. Raphael Tuck, printed in Germany; below: S.H. Kress & Co.)

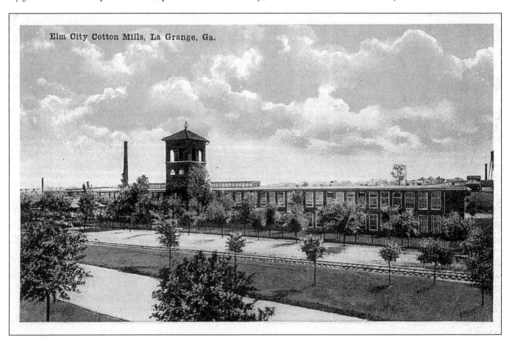

Elm City Cotton Mills, La Grange, Ga.

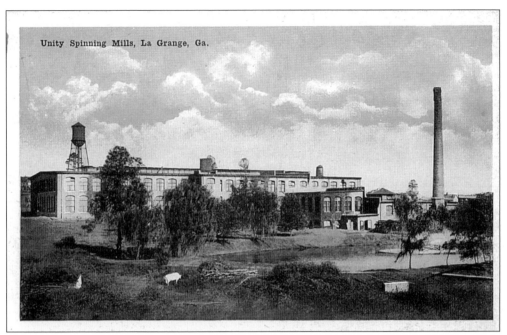

Unity Spinning Mills, built in 1909 as a division of Unity Cotton Mills, manufactured twine, cord, and yarn. Located close to Berta Weathersbee School, the plant is now known simply as Unity Mill. The first superintendents were Boyd M. Ragsdale and Samuel Y. Austin. (S.H. Kress & Co.)

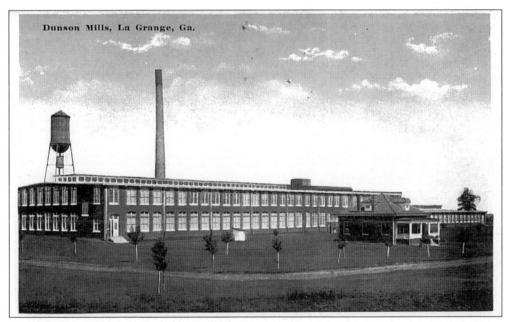

Once the largest mills in LaGrange, Dunson opened in 1910. Dunson brothers Joe, Albert, S.H., and Edgar and nephew Sanford led investors, including A.H. Cary, W. E. Morgan, F.M. Ridley, and W.A. Reeves, in building the mill. Purchased in 1952 by Pepperell, which merged with West Point Manufacturing in 1965, the plant is part of WestPoint Stevens. The house in front serves as the office and a mill entrance. The card is postmarked 1926.

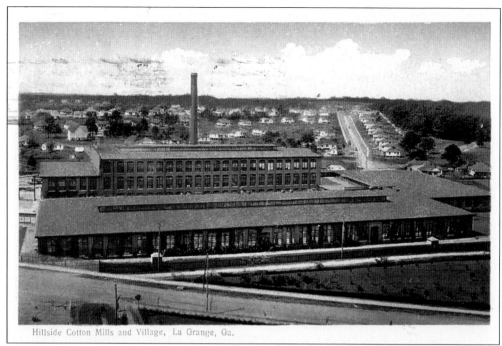

Hillside Cotton Mills and Village, La Grange, Ga.

Built in 1915, Hillside Cotton Mills contained a dye house and machinery—making a variety of products and colors possible. Hillside was the parent plant of Valley Waste Mills, seen in the card below with its attractive park, Valley Rug Mills, Rockweave Mills, and Oakleaf Mills. Investors included Callaways, Truitts, Dallises, Halls, Cleavelands, Lovejoy, Hudson, Milam, and many others. The top card was postmarked 1924. (Both cards: S.H. Kress & Co.)

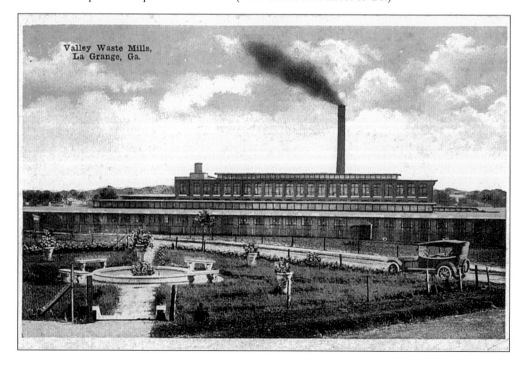

Valley Waste Mills, La Grange, Ga.

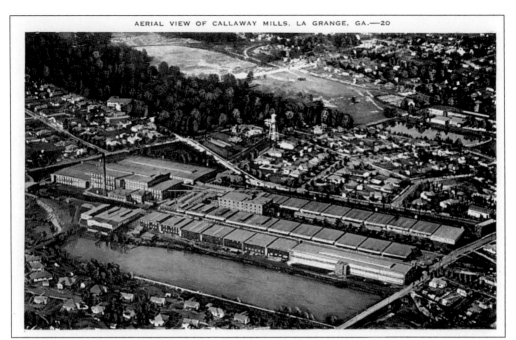

This aerial view of Hillside Plant of Callaway Mills depicts the mill village. Beginning in 1888, each mill constructed homes for its employees who otherwise would not have had housing. Each village also included churches, schools, parks, and other amenities to enhance the lives of workers and their families. (Courtesy of Charles Hays. E.C. Kropp, Milwaukee.)

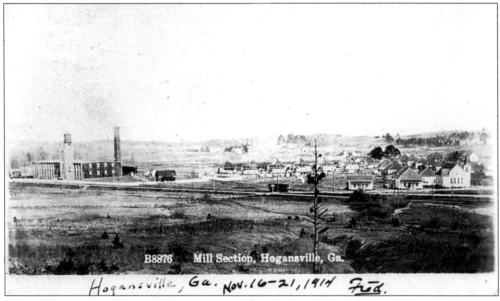

This 1914 postcard of Hogansville Mill was produced about 10 years before construction of Stark Mill by New England Southern across the railroad tracks. Callaway Mills bought Stark, along with this mill, and sold both to U.S. Rubber in 1931. A local woman and chemist, Lena E. Martin worked here during World War II, gaining national attention as a colorist. (Courtesy of Gary Doster. M.L. Zercher, Topeka, Kansas.)

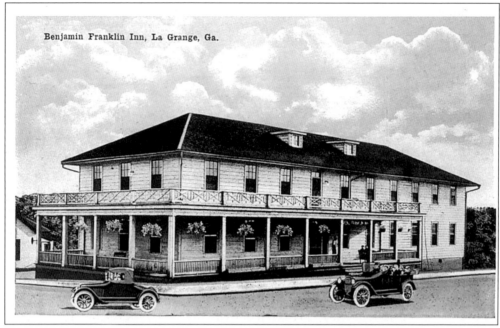

Benjamin Franklin Inn, La Grange, Ga.

The print on the back of postcards of Martha Washington and Ben Franklin Inns declares "A select home for . . . employees of Hillside Cotton Mills. Steam heat, electricity, hot and cold water, screens—every modern comfort." The Franklin, pictured above with two *c.* 1914 cars and postmarked 1917, housed single men. Located on Dallis Street, the Washington, below, was for "women and girls" and later became the general offices of Callaway Mills. A two-story brick building replaced it, which Milliken gave to Troup County. (Above: S.H. Kress & Co.; below: courtesy of Gary Doster.)

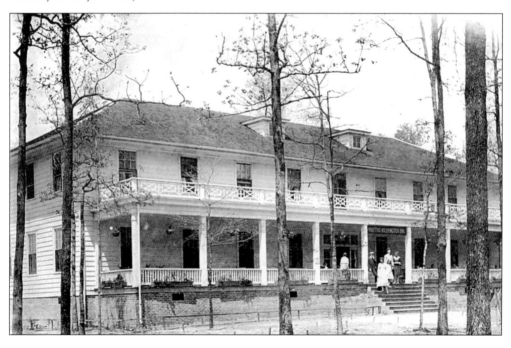

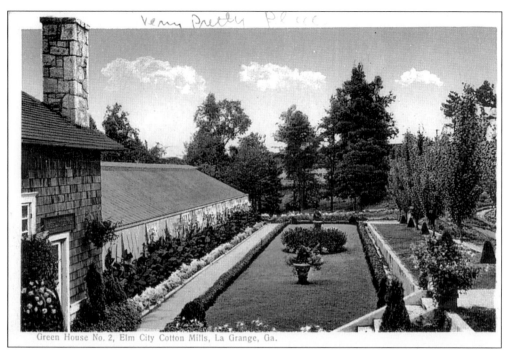

Green House No. 2, Elm City Cotton Mills, La Grange, Ga.

One unexpected pleasure of living in Callaway mill villages was the emphasis on beautification. Employees were assisted in keeping yards attractive and tables loaded with fruits and vegetables by mill-owned greenhouses. The staff grew plantings for flowers and vegetable gardens. Someone has written "very pretty place" on the card at top, which shows the greenhouse for Elm City. The bottom card is from the Hillside area. (Both cards: S.H. Kress & Co.; above: courtesy of Charles Hays.)

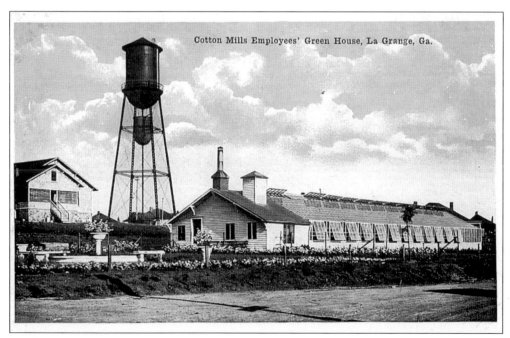

Cotton Mills Employees' Green House, La Grange, Ga.

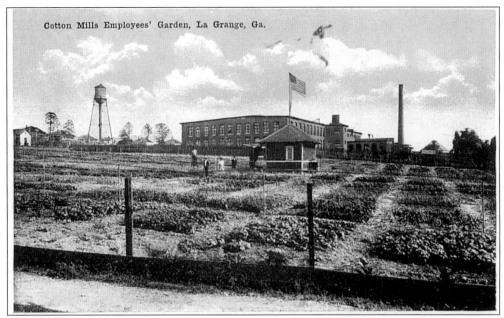

The description on this card reads "one of the Boys and Girls Gardens . . . equipped with Skinner Irrigation Systems to insure against damage" from drought. The children, who lived in Callaway Mill villages, owned the products they grew and competed for prizes. (S.H. Kress & Co.)

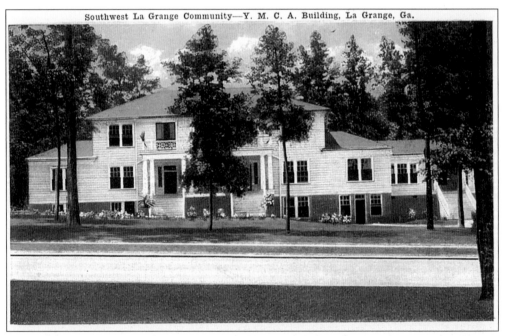

Built next to the Martha Washington Inn, Callaway Mills furnished the LaGrange YMCA—designed by noted Georgia architect Neel Reid—for its employees. The recreation facility included a wing for women and girls as well as a large gym, social and game rooms, a banquet hall, and more. Callaway Educational Association gave its 1965 replacement building to LaGrange College in 1992. (S.H. Kress & Co.)

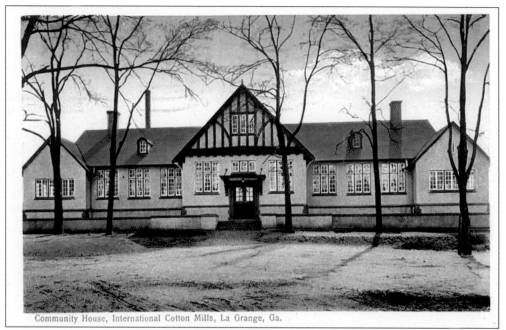

Community House, International Cotton Mills, La Grange, Ga.

The card above, postmarked in August 1929, shows International Cotton Mills Community House in LaGrange. The house had an identical twin in Hogansville. They served the social and educational needs of their respective villages. (S.H. Kress & Co.)

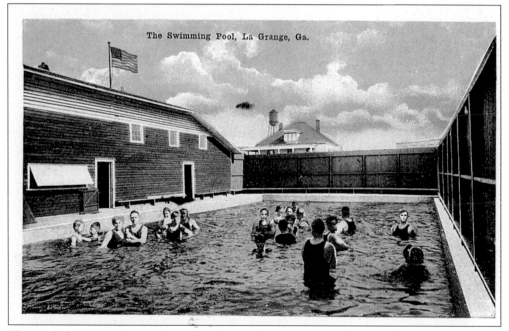

The Swimming Pool, La Grange, Ga.

This card shows people enjoying one of the early swimming facilities built in the various mill villages; this one was in Southwest LaGrange. The mills also furnished ballparks; kindergartens; theaters; classes in art, music, and dance; and more. (S.H. Kress & Co.)

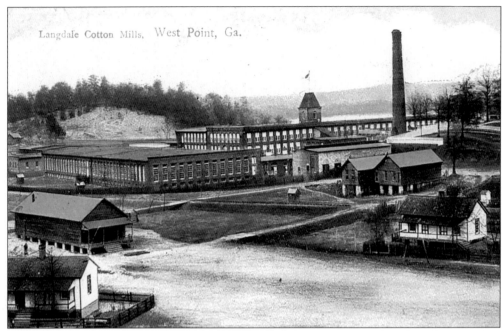

Langdale Mill was constructed between 1866 and 1869 and incorporated as the Chattahoochee Manufacturing Company. In 1880 it was reorganized as West Point Manufacturing Company, with general offices in the Lanier Building in West Point. This was the only mill owned by the company until Lanett Mill was completed in 1894. (T.J. Mattox.)

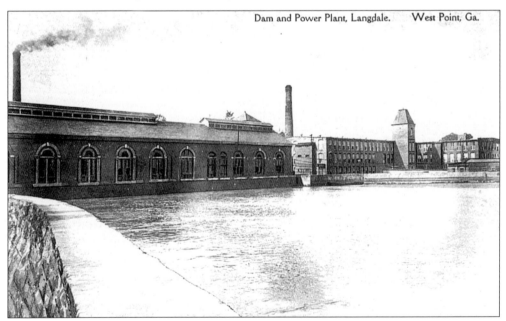

Langdale Mill extended partially over the Chattahoochee River to utilize water power. Since the state line follows the west bank of the river, part of the mill is in Harris County, Georgia. The mill was named for Thomas Lang and his son William T. Lang, who came from England to supervise mill operations. (Albertype Company, Brooklyn.)

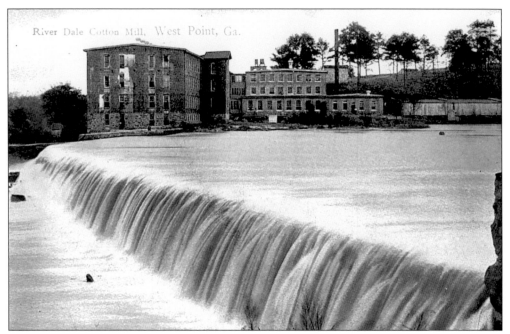

Cornerstones for both Riverdale and Langdale Mills were laid on August 1, 1866, and both mills began production in December 1869. Riverdale Mill, originally the Alabama and Georgia Manufacturing Company, was reorganized in 1892 as Galeton Cotton Mills and as Riverdale Cotton Mills in 1898. The adjacent mill village became known as River View. The card is postmarked 1910. (T.J. Mattox, Montgomery. Made in Germany.)

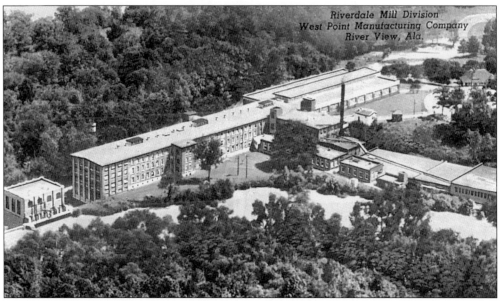

Riverdale Mill became part of West Point Manufacturing Company in 1921. Like Langdale, this mill utilized water power and was built into the river. Part of the building stood in Georgia, though not apparent in this 1940s aerial view. Several large islands in the river sit directly behind the mill. (Curteich.)

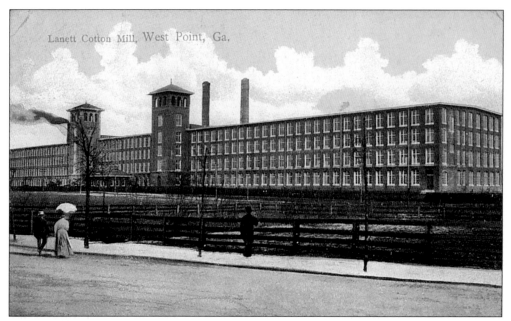

Lanett Mill, organized in 1892, began production in 1894. The village of Bluffton, across the Alabama line from West Point, incorporated in 1895 as the City of Lanett. "Lanett" was a combination of the names of LaFayette Lanier and Theodore W. Bennett, early textile developers in the area. (T.J. Mattox, Montgomery.)

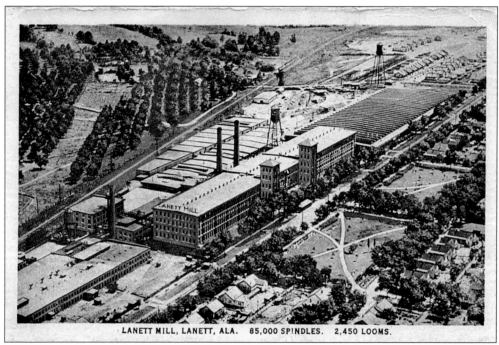

This early 1940s card, postmarked 1947, shows an aerial view of Lanett Mill, the largest mill of West Point Manufacturing Company. The highway parallel to the mill is U.S. Highway 29, and the rail line to Montgomery runs behind the mill. (R.J. Shutting, Chattanooga, Tennessee.)

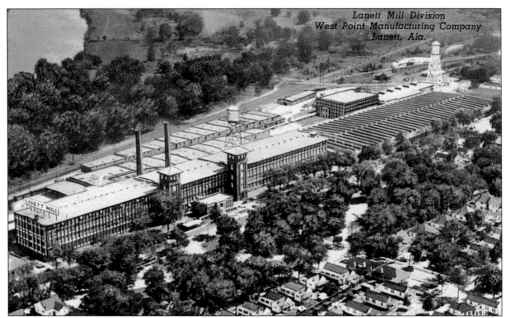

Another 1940s aerial view shows the Chattahoochee River in the background and part of the extensive mill village in the foreground. West Point Manufacturing Company owned the mill houses until 1953, when they were sold to employees. The back of the postcard advertised the Valley Cotton Festival—a week of festivities that included appearances by the governors of Georgia and Alabama. (Curteich.)

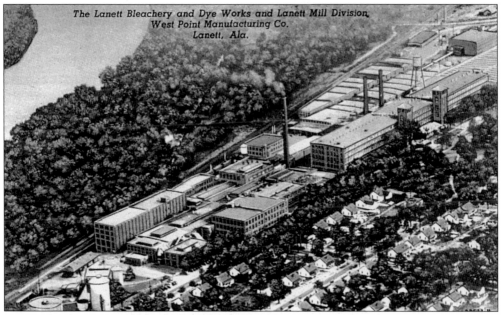

Lanett Bleachery and Dye Works, on the north end of Lanett Mill, began operations in 1895, bleaching and dyeing fabrics made at Lanett, Langdale, and Riverdale Mills. For years, it was one of the two largest of its kind in the nation. In contrast to the bottom postcard on the previous page, this card shows that the Dye Works has been considerably expanded. (Curteich.)

79

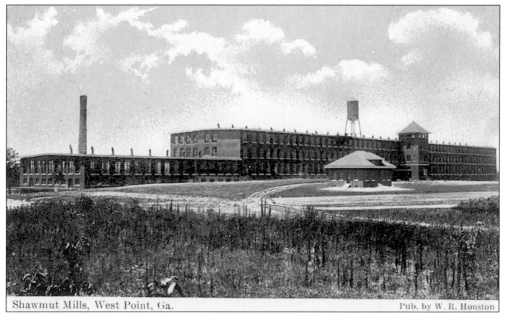

West Point Manufacturing Company built Shawmut Mill in 1907 between Lanett and Langdale mill villages. The name Shawmut, an Indian word meaning "living springs," was associated with early Boston, Massachusetts. Horace Sears, Boston-based treasurer of West Point Manufacturing Company, suggested the name. The card is postmarked 1929.

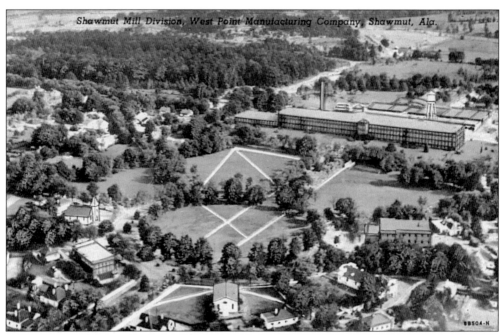

This 1940s aerial view of Shawmut Mill and its adjacent mill village shows the unique design used by its planner William Bell Marquis, landscape architect and town planner. School, church, and community buildings occupy a central circle with an open green space. Main streets run outward like spokes of a wheel, similar to Washington, D.C. (Curteich.)

80

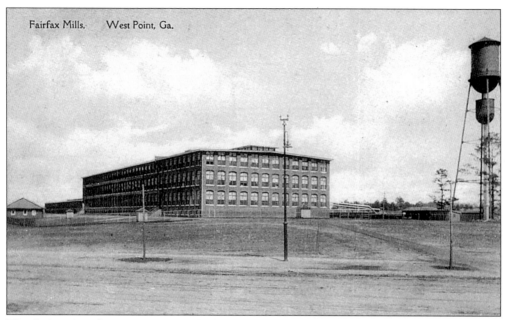

Fairfax Mills. West Point, Ga.

West Point Manufacturing Company built Fairfax Mill in 1915, between Langdale and River View. This card, from a photo taken soon after construction, shows the surrounding area devoid of trees. A mill village grew up around the mill. The villages of Shawmut, Langdale, Fairfax, and River View remained unincorporated until 1980, when they merged into the new city of Valley, Alabama. (Courtesy of Gary Doster. Albertype Co., Brooklyn.)

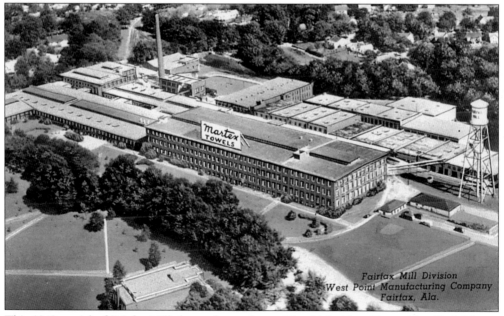

Fairfax Mill Division
West Point Manufacturing Company
Fairfax, Ala.

This 1940s aerial of Fairfax Mill shows the product with which this mill was identified. Martex towels were nationally recognized and probably the most popular product of West Point Manufacturing Company. A towel shop in the mill was a popular tourist attraction, evolving into WestPoint Stevens' present Mill Store near Interstate Highway 85. (Curteich.)

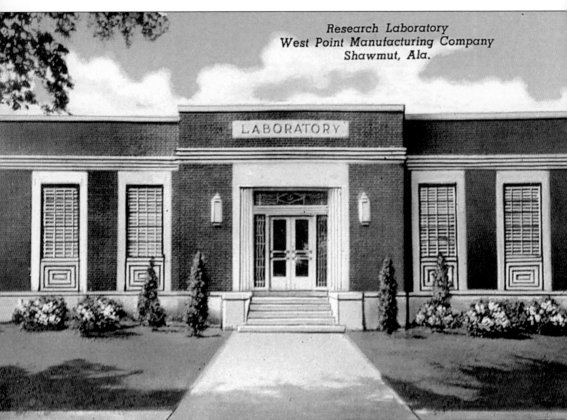

Research Laboratory
West Point Manufacturing Company
Shawmut, Ala.

LABORATORY

This Shawmut structure was built in 1937 and became the Central Testing Laboratory after the Research Division moved to the former cafeteria building in 1950. Johnston Industries now owns the building. Walls in this building contained murals made from photos taken by noted national photographer Margaret Bourke-White, which had been commissioned by West Point Manufacturing Company. The five textile mills of West Point Manufacturing Company (later West Point Pepperell and now WestPoint Stevens) are located in Chambers County, Alabama, on the west side of the Chattahoochee River. Early cards are identified as being from West Point, Georgia, since the general offices were there and mill villages, other than Lanett, were not incorporated towns. (Curteich.)

Six

SCHOOLS

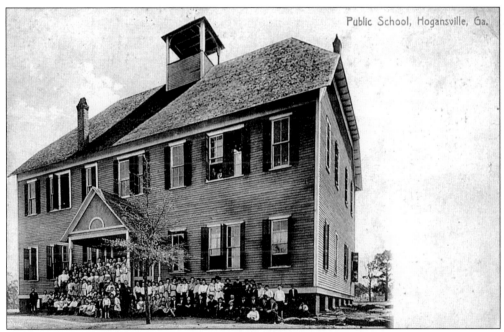

Public School, Hogansville, Ga.

When voters of Troup County or its cities adopted a public school system, many schools went from being private to public, as was the case with this Hogansville school in 1893. Built on Johnson Street, the school served all grades until burning in 1919. A three-story brick building stood on the site until the mid-1950s. Sometimes known as Hogansville Institute, this building was also called by the principal's name—such as the Looney or Covin Institute. The card is postmarked 1912. (Holt & Cates Co., Newnan, Georgia. Made in Germany.)

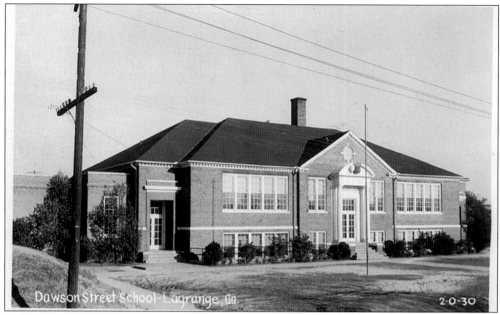

Built in 1937, Dawson Street School served elementary children. Daniel Lumber Company constructed the school, which replaced an older one that burned. The LaGrange school system used Dawson Street until 1990 when the school was given to the City of LaGrange. The building is now home to the Alpha Multipurpose Center and a private school.

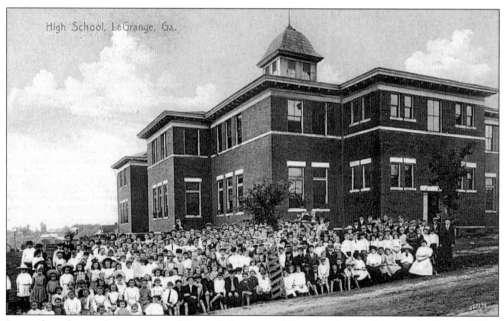

Located on the southeast corner of Harwell Avenue and Broome Street, this was the first building erected after creation of the LaGrange Public School System in 1903. The school served elementary students after high school classes moved to a new building on North Greenwood Street in 1915. In 1939, the system built a new school across the street that stood until a fire in 1964. This building burned in 1943. (Printed in Germany.)

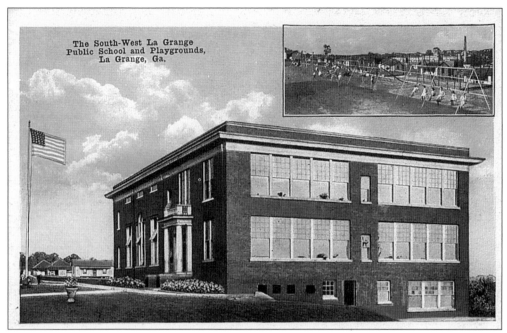

The South-West La Grange Public School and Playgrounds, La Grange, Ga.

Southwest LaGrange School opened in October 1916 for students from the surrounding Callaway Mill Villages. The school became part of the LaGrange City system in 1919. After a fire in 1928, restoration led to the building shown here, which served students until 1952 when a new building was constructed. Renovations in 2001 enabled the 1952 building to continue housing students in the 21st century. (S.H. Kress & Co.)

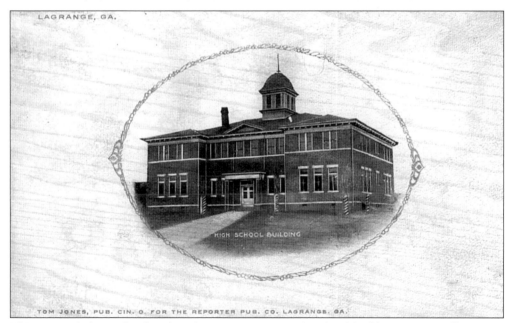

LAGRANGE, GA.

HIGH SCHOOL BUILDING

TOM JONES, PUB. CIN. O. FOR THE REPORTER PUB. CO. LAGRANGE, GA.

This postcard shows the then brand new LaGrange High School building on Harwell Avenue. Tree guards protected each of the newly planted trees. An additional wing seen in the postcard at left had not yet been built. (Tom Jones, Publisher, Cincinnati, Ohio, for Reporter Publishing Co.)

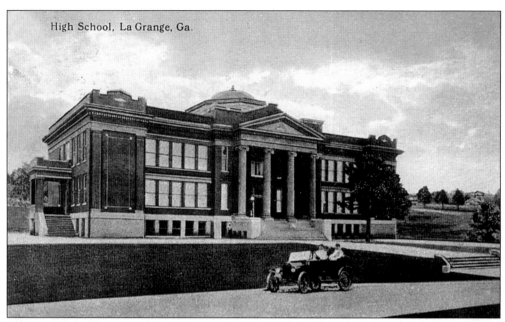

High School, La Grange, Ga.

The card above shows the first LaGrange High School building on North Greenwood Street, completed in 1915. The school burned on December 26, 1942. Because of wartime pressures, builders did not finish the school, shown below, until 1947. In the meantime, the school operated out of First Methodist Church. William J.J. Chase, who designed the Art Deco courthouse in 1939, designed the Art Moderne structure. (Above: C.T. Doubletone; below: Curteich.)

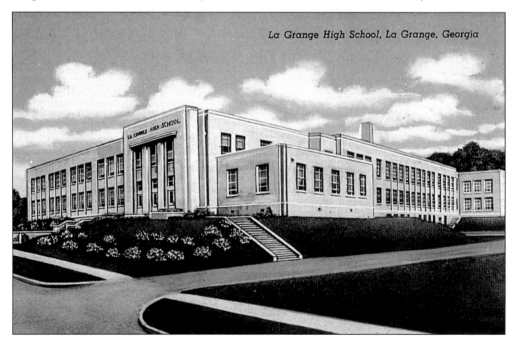

La Grange High School, La Grange, Georgia

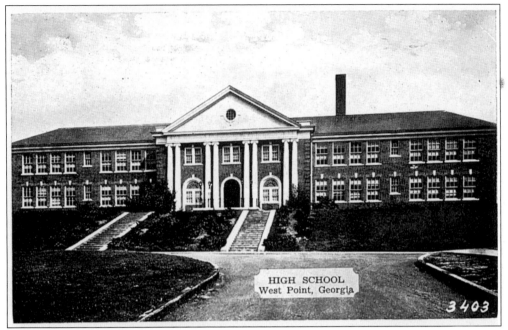

Although labeled "High School," this building housed 11 grades (increased to 12 in 1948) and a kindergarten until 1952, when a new high school was built. Located on "College Hill," this building stood on the former site of West Point Female College. Designed by Macon architects Dennis & Dennis, the building was constructed in 1930. The card is postmarked 1947. (Dexter Press, Pearl River, New York.)

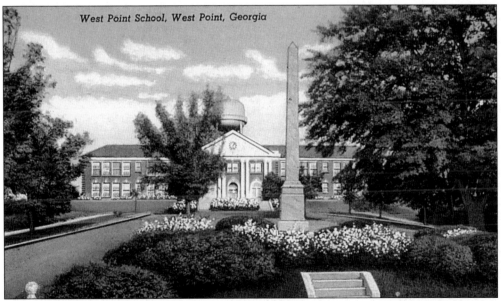

This view of the same school building shows the Confederate Monument at the foot of College Hill, where it was moved in 1923. Since consolidation of West Point and Troup County schools in 1986, the building has been vacant. It was added to the National Register of Historic Places in 1999. The monument was moved west of the river, adjacent to Fort Tyler, in 1995. (Curteich.)

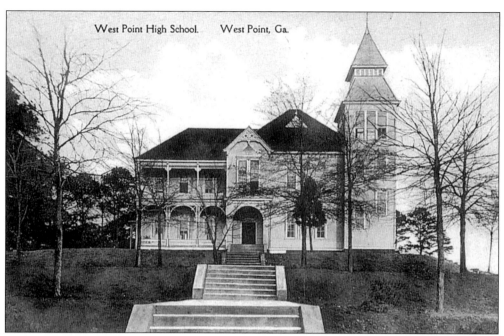

West Point High School. West Point, Ga.

Built in 1887, West Point School was constructed on the site of the old West Point Female College, which gave the site its name, College Hill. The West Point public school system opened in 1876. This school was demolished in 1929. (Albertype Co., Brooklyn.)

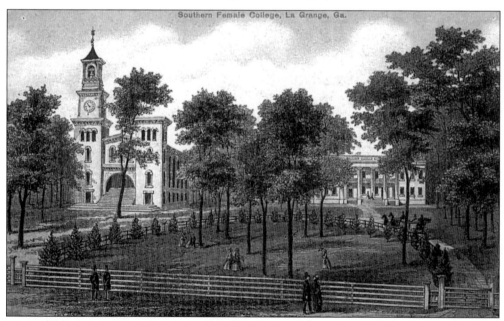

Southern Female College, La Grange, Ga.

The original campus of Southern Female College is shown here. Chartered in 1842, the buildings sat on Greenville Street, one block east of Hill Street. The entire facility burned in 1864 while serving as a Confederate hospital. An old etching enabled the postcard to be created a generation after the college was destroyed. This card was apparently part of a fund-raising campaign following another fire in 1908. (Newvochrome. Printed in Germany.)

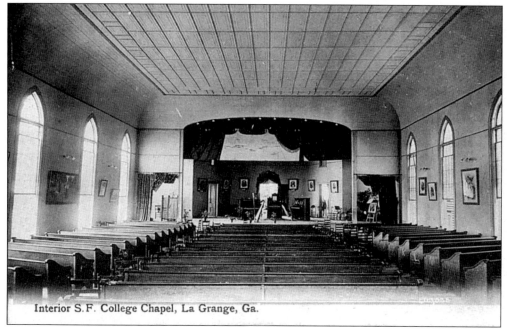

Interior S.F. College Chapel, La Grange, Ga.

The interior of the Sarah Ferrell Lyceum, which served as the chapel of Southern Female College at the school's Church Street site, is seen here. Horace King laid the building's cornerstone in an elaborate ceremony in 1877. (Photographed and published by J. L. Schaub of LaGrange. Printed in Great Britain.)

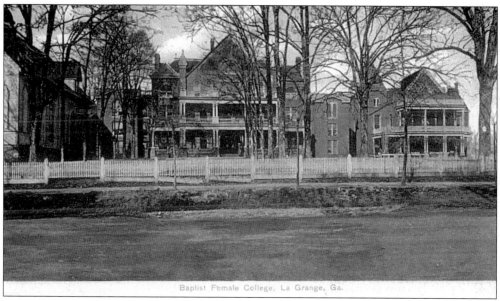

Baptist Female College, La Grange, Ga.

The final campus of Southern Female College occupied the entire block between Church, Battle, Smith, and North Lewis Streets. The main building, shown in the center, was erected in 1868–1869 and altered in 1887 by budding architect/builder W.S. Cox, son of the college president. Behind the main building and to the right were dormitories. The Lyceum stands partially visible on the left. (American News Co., New York. Printed in Germany.)

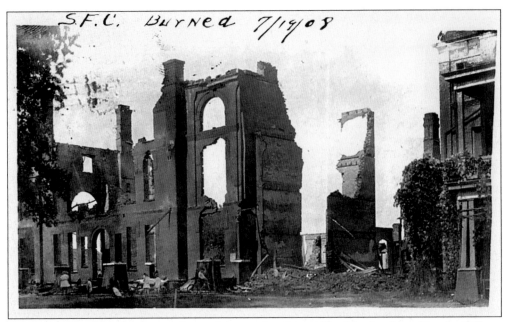

S.F.C. Burned 7/19/08

This real-photo card shows one of several devastating fires suffered by Southern Female College. The fire occurred on July 18, 1908, and destroyed almost everything seen in the card at the bottom of page 89. The message on the back was written just 11 days later, though the writer made no mention of the fire. Uninsured fires like this one contributed to closing the institution in 1919.

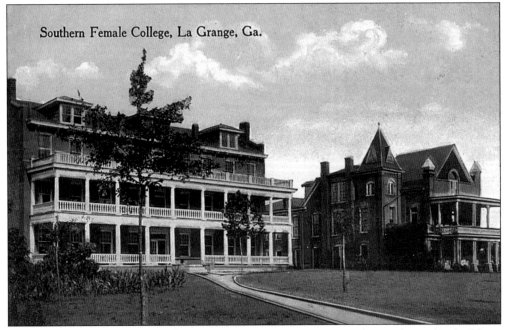

Southern Female College, La Grange, Ga.

This is how Southern Female College appeared at its closing in 1919. The campus and its buildings were given to the largest creditor, Lewis Render, who sold it to the Daniel Brothers. They, in turn, created the Render Apartments that remained until the early 1960s. A U.S. Post Office operated at the site until 1999. (Published by S. H. Kress & Co.)

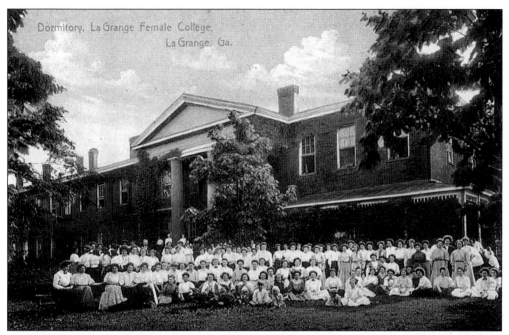

Students and faculty at LaGrange Female College gathered in front of Oreon Mann Smith Hall, the school's oldest building. Smith Hall bore the name of the wife of college president Rufus W. Smith. Fittingly, this card was printed in Germany as many of the faculty of its renowned music department either studied at Leipzig or were from Germany, including Alwyn M. Smith, music chair and son of President Smith.

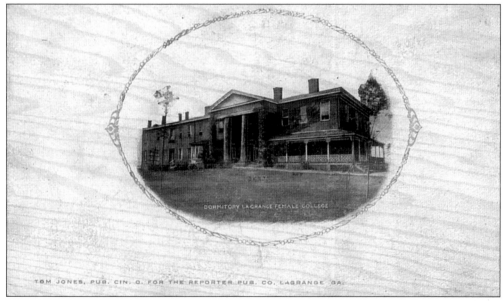

This card shows with more clarity the four famous columns of Smith Hall, known as Matthew, Mark, Luke, and John. The right half of the building may date to 1836, with a major restoration after an 1860 fire. George King added the Victorian porch and the left wing of the building in 1887. (Tom Jones, Publisher, Cincinnati, Ohio, for Reporter Publishing Co.)

The postcard above shows the east facade of Dobbs Auditorium before construction of Harriett Hawkes Hall. The north end of Smith Hall stands in the background. The picket fence across the front, a standard feature around homes and buildings, kept stray animals out of gardens. The card below shows the west side of Dobbs Auditorium with its beautiful Palladian entrance and Harriett Hawkes Hall with its two-tiered porch. Park A. Dallis designed Hawkes in 1911. (Above: Bradfield Drug Co.; below: Commercialchrome.)

LA GRANGE COLLEGE.
LA GRANGE, GA.

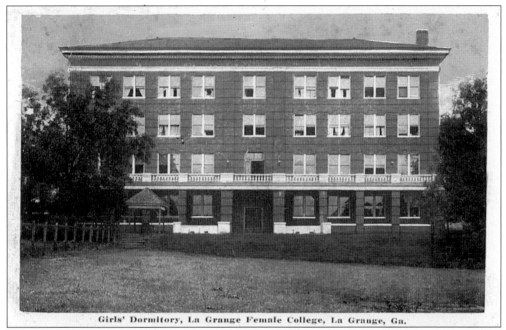

Girls' Dormitory, La Grange Female College, La Grange, Ga.

The postcard above shows the southern exposure of Hawkes Hall. A.K. Hawkes gave this building in memory of his mother, a LaGrange College alumna. He also donated Hawkes Library in West Point. The card below, postmarked 1964, features an aerial view of the campus and appears to date from the early 1960s, before construction of the Chapel and Banks Library. (Above: S.H. Kress & Co.; below: Photo by Bill Holt, used with permission. Printed by Tichnor Brothers, Boston.)

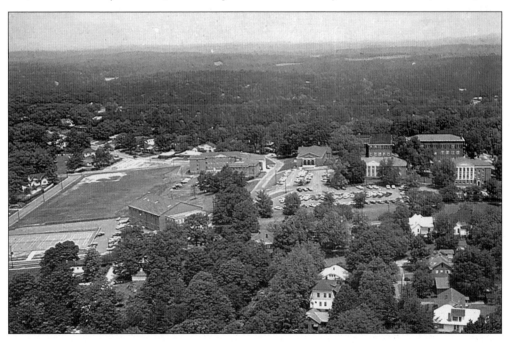

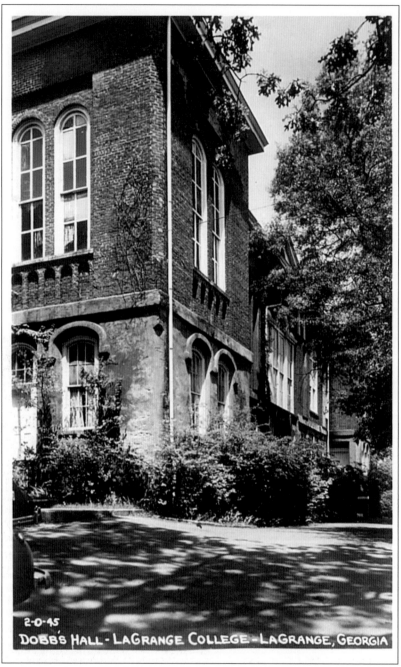

2-0-45

DOBB'S HALL - LAGRANGE COLLEGE - LAGRANGE, GEORGIA

The Montgomery Brothers built Dobbs Hall as a classroom and auditorium building after they bought and moved LaGrange Female College to the Hill in the 1840s. The school proudly proclaimed its auditorium to be the largest south of the Potomac. It had massive three-story wooden Doric columns that were not replaced after a fire in 1860. The building as seen here was restored in the 1870s by Horace King, completing work started by Benjamin Cameron. Another fire in 1970 rendered the building a total loss. The school erected the Fuller E. Callaway Building that featured similar design details.

Seven

CHURCHES

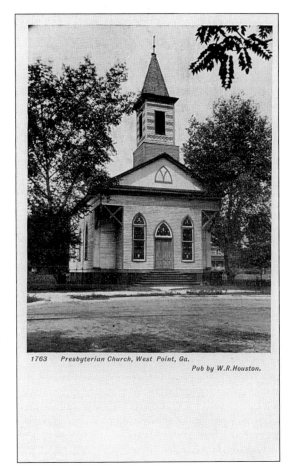

1763 Presbyterian Church, West Point, Ga.

Pub by W.R. Houston.

Churches have been at the core of every community and a central part of life since the founding of Troup County. In 1852, black carpenters erected the first building for the Presbyterian Church of West Point. It had an identical twin in Lafayette, Alabama, which now serves as an annex to the public library. Located on present-day Fourth Avenue and West Seventh Street, the building is said to have straddled the state line so that the preacher stood in Alabama while the congregation sat in Georgia! The 1920 cyclone destroyed this building. (W.R. Houston.)

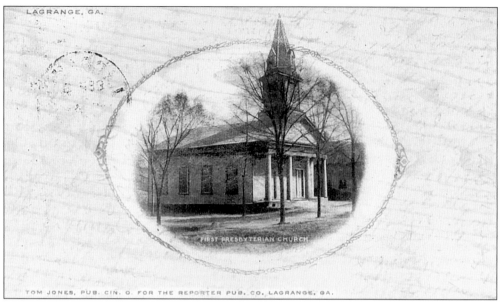

These two postcards give an excellent view of the oldest remaining church building in LaGrange. Benjamin H. Cameron built the First Presbyterian Church on Church Street at West Haralson in 1844. John King added the steeple seen here in 1886. The steeple replaced an earlier one that had blown off. (Tom Jones,Publisher, Cincinnati, Ohio for the Reporter Publishing Co.)

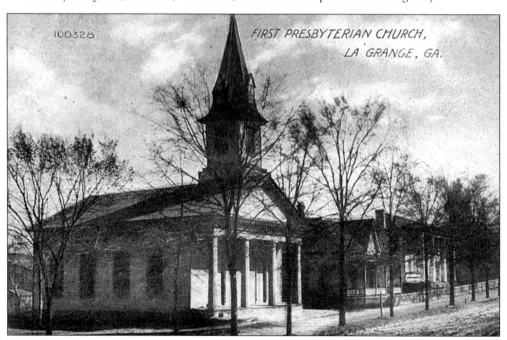

In addition to the church, two homes belonging to Mrs. George B. Heard are shown in this postcard, which looks south on Church Street from West Haralson. When the First Presbyterian Church moved in 1922, the church building became a funeral home and other businesses before becoming a church again in 1990. This is now home to Covenant Presbyterian Church. (Cash Book Store.)

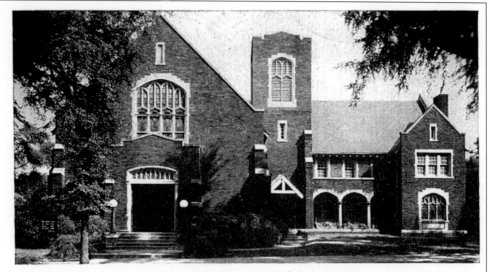

First Presbyterian Church
LaGrange, Georgia

Built by Calhoun Construction of Anniston, Alabama, in 1921, First Presbyterian Church suffered serious damage in a fire in 1951. Restoration by Newman Construction Company added a Gothic foyer to the front of the otherwise Tudor exterior. The building stands on the northeast corner of Broad and North Lewis Streets on a lot donated by Miss Laura Loyd. (Courtesy of Charles Hays.)

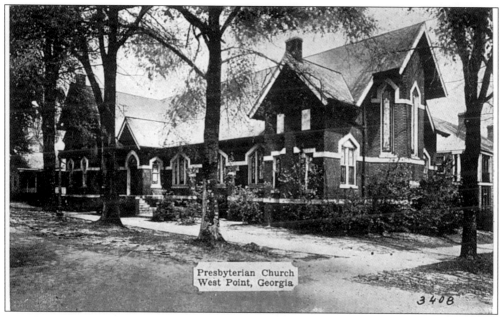

West Point Presbyterians first organized in 1837 and constructed the building shown on page 95. They dedicated this still-used church building in 1923 at the corner of West Tenth Street and Fifth Avenue on the west side of the river. This card dates from the mid-1940s. (Dexter Press, Pearl River, New York.)

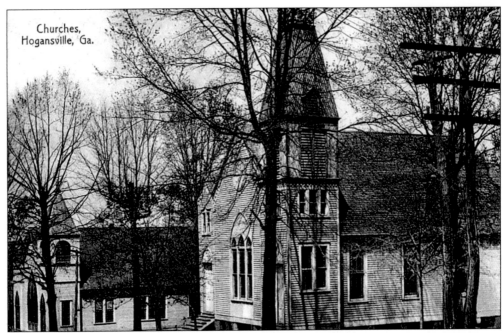

Churches,
Hogansville, Ga.

In Hogansville, the downtown churches have been side-by-side since 1896. The Methodist church, on the left, and Presbyterian church are both Victorian Gothic in style. Missing from the scene is the Baptist church. Neither of these buildings remain as seen here, though both structures for the churches are on the same sites today. (Holt and Cates Co., Newnan, Georgia. Made in Germany.)

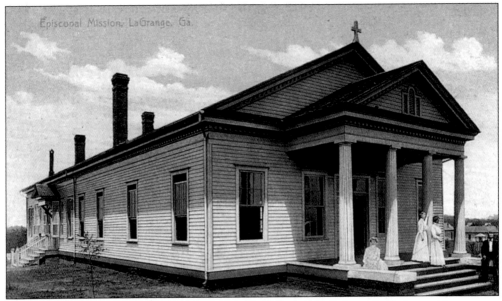

Episcopal Mission, LaGrange, Ga.

Located on Murphy Avenue, this was the original building of the Episcopal Mission, a joint venture of the Episcopal Church and the Truitt-Callaway Mills (a forerunner of Callaway Mills), as was the hospital seen in the postcard opposite. Both catered to mill employees and their families in Southwest LaGrange. (Made in Germany.)

98

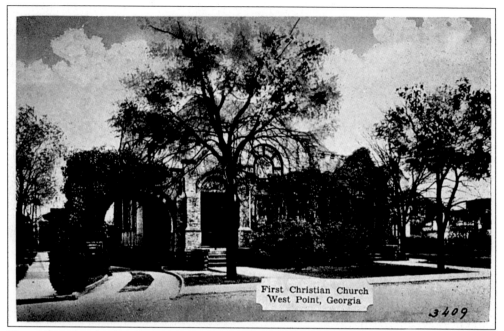

First Christian Church
West Point, Georgia

3409

First Christian Church of West Point, constructed in 1906-1907, was located on the corner of Railroad Avenue (Second Avenue) and West Ninth Street, on two lots donated by Frank and Henry Lanier. Earlier, members met in various homes, the Masonic Hall, and the old Opera House. The building was demolished for highway construction and a new church built in Lanett in 1969. (Dexter Press, Pearl River, New York.)

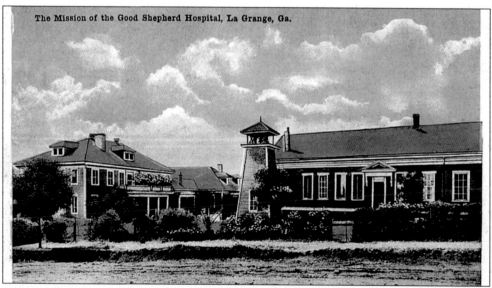

The Mission of the Good Shepherd Hospital, La Grange, Ga.

The Episcopal Church and Callaway Mills constructed these buildings in 1911. Among those at the dedication were Georgia governor-elect Hoke Smith. The Mission of the Good Shepherd operated until 1932. One of the wings held the hospital and infirmary while the other held the nurses' home. For a brief time in the mid-1910s, this was the only hospital in LaGrange. The buildings were later split into two houses. (S.H. Kress & Co.)

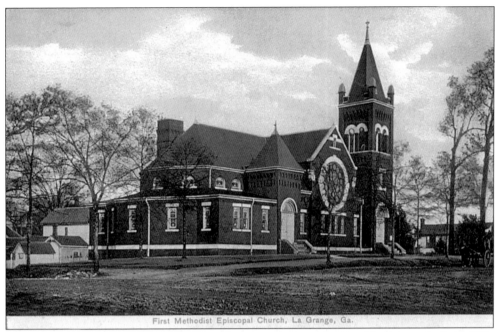

First Methodist Episcopal Church, La Grange, Ga.

These two postcards show different sides of First Methodist Church of LaGrange, built in 1898. Part of the Belgian stained-glass windows in the main building were incorporated into the chapel at LaGrange College in 1964, when this building was torn down to erect a larger sanctuary. The card below, postmarked 1910, also shows the old church parsonage that was razed in 1937 for a Sunday school building. (Above: American News Co., New York. Made in Germany; below: Bradfield Drug Co.)

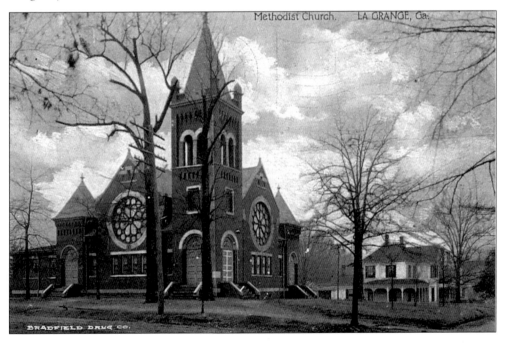

Methodist Church. LA GRANGE, Ga.

BRADFIELD DRUG CO.

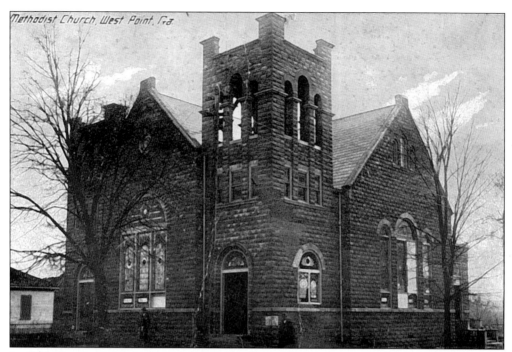

In 1830 West Point Methodists organized the first denomination in the city. In 1852 West Point Land Company donated a lot to the church at the corner of present-day East Seventh Street and Avenue C. They built a brick structure that was demolished in 1905. The present structure, shown above, was completed in 1907. The interior has barrel vaulting and it is constructed of concrete blocks to simulate stone. (Postmark 1915.)

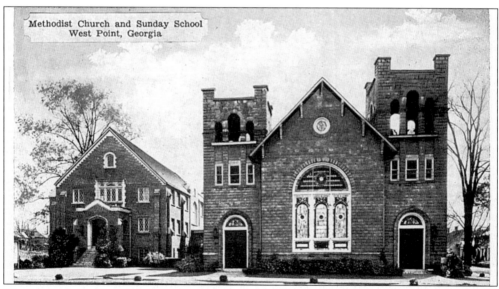

The Sunday school building, left of the church, was constructed in 1927 by West Point Iron Works for $30,100. Dennis and Dennis architects of Macon designed the structure. Both the church and Sunday school building have undergone extensive renovations in recent years, but exterior views remain much the same as shown in this card of the mid-1940s.

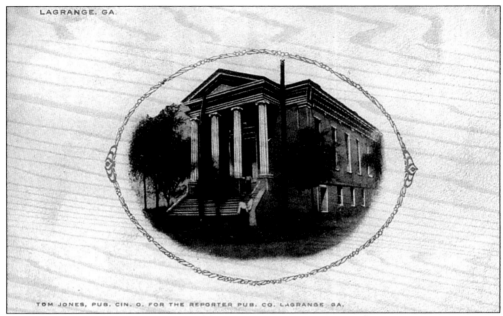

The original structure of First Baptist Church was built on the Square at the corner of Broad and Church Streets in 1855. Several renovations altered the appearance of the front of the church over the years. The sidewall seen on the right stood until 1995 when the entire building was torn down and replaced. (Tom Jones, Publisher, Cincinnati, Ohio, for Reporter Publishing Co.)

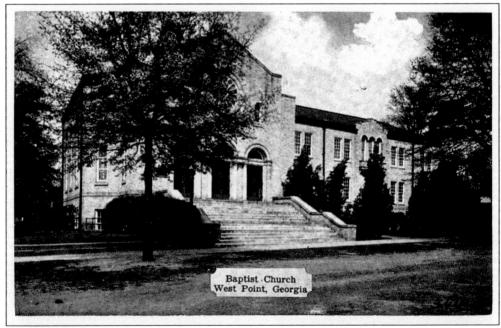

Baptist Church
West Point, Georgia

West Point Baptists organized in 1849 and the present church building was erected in 1925 for a cost of $115,000. The two-and-a-half story white brick building is located at the corner of East Eighth Street and Avenue C. The style is Spanish Colonial Revival, and the card is postmarked 1947. (Dexter Press, Pearl River, New York.)

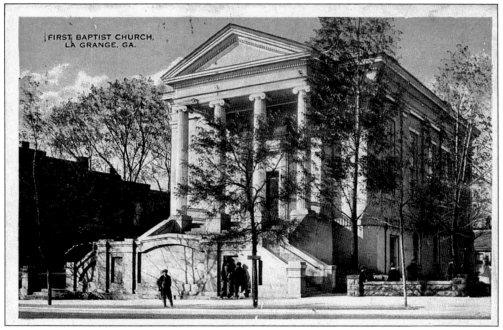

These two cards illustrate dramatic changes made to the facade of the First Baptist Church of LaGrange. This shot was taken before 1922 when renovations included the addition of stained-glass windows that were reused in 1997 in the current structure. (Commercialchrome.)

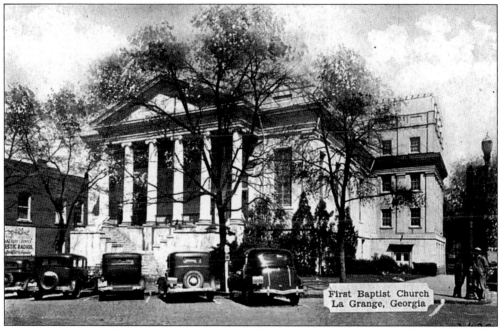

This card shows First Baptist Church after a reconfiguration of the front steps and the addition of two columns to the portico. The absence of a steeple that blew down in 1882 was remedied in 1970 with a gift from Alice Callaway. The same steeple was reused on the new edifice and adapted to house carillons, also a gift from Mrs. Callaway. (Dexter Press, Pearl River, New York.)

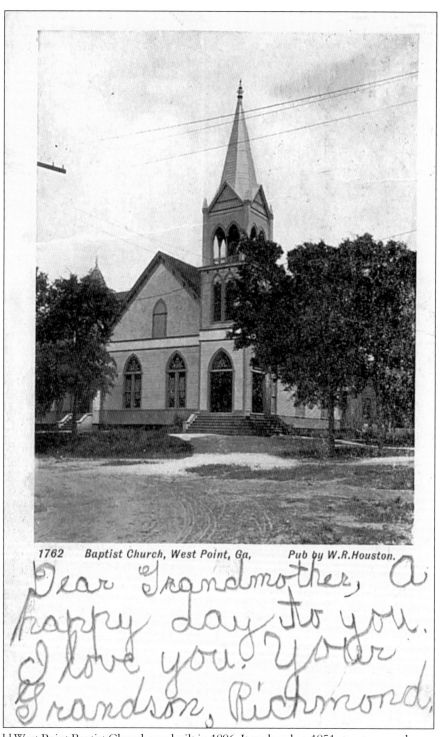

1762 Baptist Church, West Point, Ga, Pub by W.R.Houston.

Dear Grandmother, A happy day to you. I love you! Your Grandson, Richmond,

The old West Point Baptist Church was built in 1896. It replaced an 1851 structure on the same lot, donated by the West Point Land Company. The church was demolished in 1925 and replaced by the present building. (Postmark 1907. Published by W.R. Houston.)

Eight
HOMES

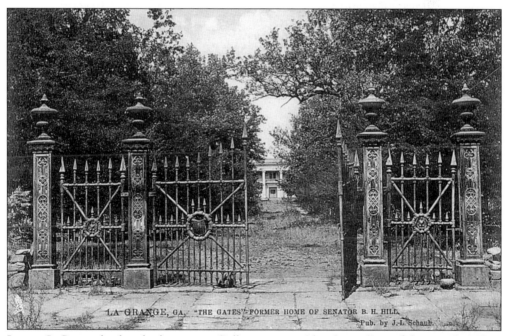

Long a LaGrange landmark, the gates to Bellevue were said to be replicas of those at the White House. The entrance to Bellevue started from Broad Street when Benjamin Harvey Hill built the home in the mid-1850s. Local photographer J.L. Schaub, who published this card, opened one gate so the house could be seen. LaGrange College now uses part of the gates as an entrance. Bellevue is the only National Landmark property in Troup County. (Tuck's Post Cards. Made in Germany.)

Another Schaub card, postmarked 1912, shows details of Bellevue, including the rooftop balustrade which no longer exists. Beautiful views of LaGrange from this roof gave the home its name. Ben Hill, one of Georgia's leading statesmen in the 19th century, served in both the Confederate and U.S. Senates. This "Souvenir Mail Card" opens to show the message handwritten under the picture. (Tom Jones, Publisher, Cincinnati, Ohio, for Reporter Publishing Co.)

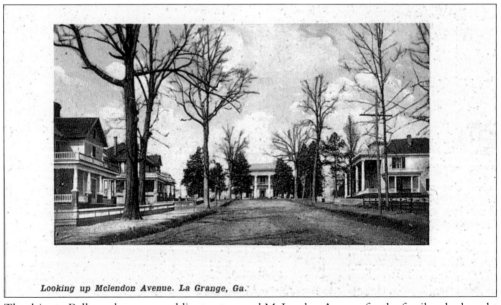

Looking up Mclendon Avenue. La Grange, Ga.

The drive to Bellevue became a public street named McLendon Avenue for the family who bought this from the Hills in 1869. When Ben Hill Road was renamed Country Club Road, this street was renamed Ben Hill Street while the drive around Bellevue remained McLendon Circle. The McLendons sold Bellevue to Callaway Foundation for the LaGrange Woman's Club, who maintains the house museum. (Sextochrome Postcard. Printed in France.)

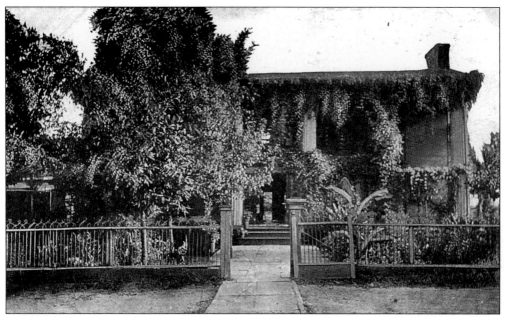

This ivy-covered six-column mansion once stood on Vernon Street where Harwell Avenue now intersects. Built in 1832 for Daniel S. Robertson, second sheriff of Troup County, the house became home to Dr. Bennett Ware. Later as the home of Col. James H. and Julia Fannin, its gardens were considered second only to those of Mrs. Fannin's sister, Sarah Coleman Ferrell. This house was later torn down. (Curteich.)

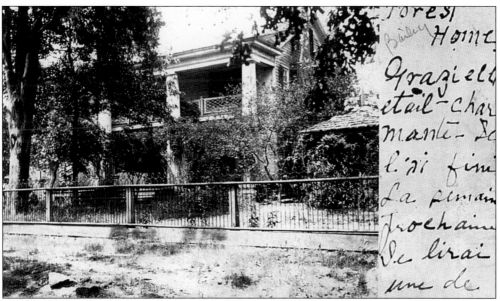

Forest Home, now also known as Rosemont Plantation, was built *c.* 1840 by Charles C. Bailey and resembled his home in Henry County, Virginia. Despite the home being several miles from town, many notables were entertained here, including Jefferson Davis, John B. Gordon, and Gov. W.H. Northen. The note on the back was postmarked LaGrange, 1912, and written in French by Bailey's granddaughter, Elizabeth R. Traylor.

107

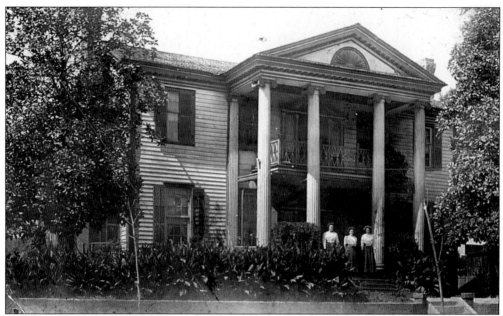

Built for Rufus Broome in 1830 by local architect Collin Rogers, this house stood on the corner of Main and Broome Streets. It bears all of the trademark features of Rogers' houses: star rosettes in the capitals of Ionic columns, fan light transoms over both doors, sheaves of wheat-style balustrades, and a central pedimented portico. In 1917, the home was replaced by LaGrange National Bank, that now houses the Troup County Archives. The card is postmarked 1908. (Courtesy of Jeanette Dunson Brooke.)

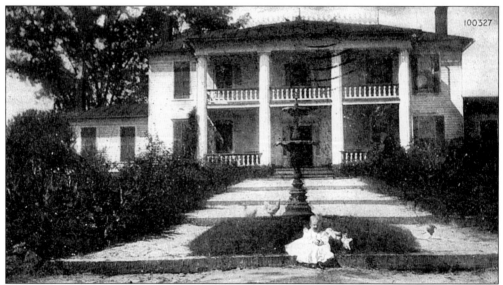

Celeste Dunson poses in front of Oakhurst, home of her uncle and aunt, Robert and Sarah Render. The house on Hill Street was originally home to Edward Y. Hill, for whom the street was named, and his wife, Annabella Dawson Hill, widely known for her cookbooks. The house served one year as Hill Street Junior High before being replaced by a school facility. The card is postmarked 1910. (Cash Book Store; courtesy of Ken Thomas.)

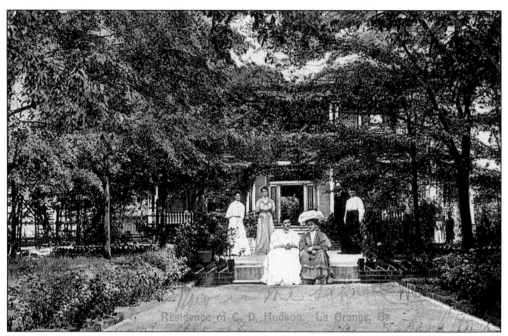

Members of the C.D. Hudson family posed at their Hill Street home. Large trees kept the home cool during hot Georgia summers. Opening the doors at both ends of the central hall helped circulate air. Of the five ladies out front, the one standing on the right is Elizabeth "Dink" Truitt Hudson. The card is postmarked 1907. (Adolph Selige, Publisher, for the Reporter Printing Co. Published in Germany.)

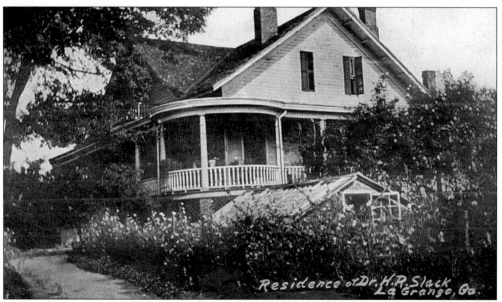

Dr. H.R. Slack gave this house—built for James Turner—a Victorian verandah when he built his private sanitarium next door on West Haralson Street. Abner Turner, the first person buried in Hill View Cemetery, died here in 1830. This was later the Nurses Home for Dunson Hospital. (Cash Book Store.)

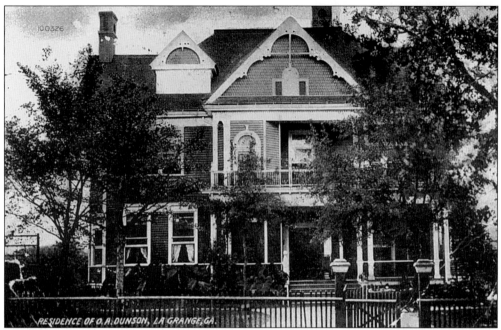

One of the many grand Victorian houses that once lined Hill Street, this one was built for Otis A. Dunson, president of Dixie Mills. The actual postcard shows the house in colors of olive green and dark yellow, popular shades at the end of the 19th century. This house burned in the 1940s.

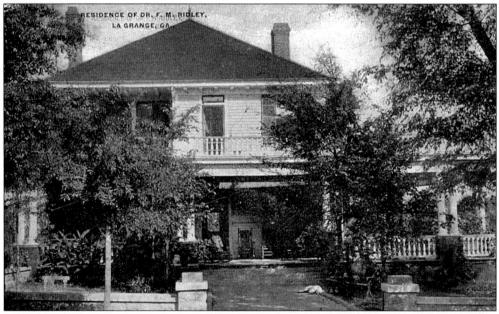

This house stood on Smith Street where the City Pool Pavilion is now located. The home was built in 1887 for Dr. F.M. Ridley after a fire destroyed his antebellum home. During construction, the family lived at Ferrell Gardens with Mrs. Ridley's grandparents. W.S. Cox and Henry E. Butler designed and built this house. The Ridleys furnished four generations of LaGrange doctors. (Published by Schaub Art Gallery.)

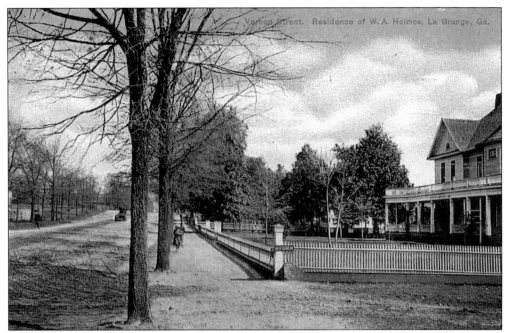

The riverboat-style porch on the home of Winn A. Holmes looks across its white picket fence to Vernon Street directly behind First Methodist Church. Taken from its intersection with Alford Street, the view looks east toward downtown LaGrange. The house was given to the church in 1962 by Eula Harris Holmes. The church razed the house for parking. (Courtesy of Charles Hays. Newvochrome. Printed in Germany.)

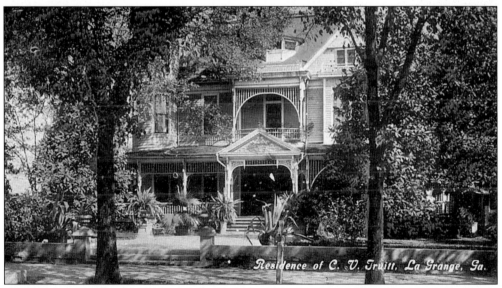

Cornelius Vanderbilt Truitt, one of the leading textile magnates of LaGrange, built this grand Victorian home in the second block of Main Street south of the Square. Today, a parking lot occupies the site. The same fine detail in this house can be seen in the house that Truitt built in 1914 at 306 Broad Street, the Truitt-Mansour home. The card is postmarked 1911. (Cash Book Store. Made in the USA.)

111

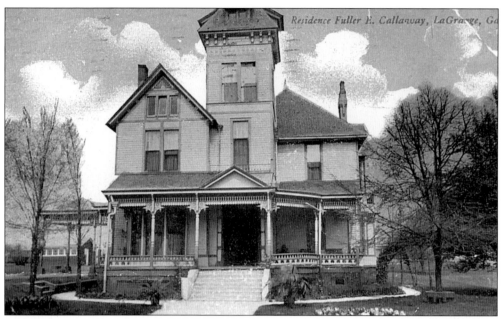

William C. Yancey had this house constructed for his wife. Earlier, the same architect built its twin for LaFayette Lanier in West Point. Known as Buckingham Palace, this stood on Broad Street and Springdale. This was the home of Fuller and Ida Callaway before they built Hills and Dales. The message on back is handwritten by six-year-old Fuller Callaway Jr. The card is postmarked 1913; the house was razed in 1959. (Schaub's Art Gallery.)

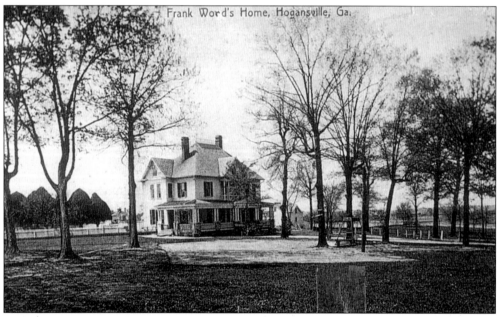

This Victorian home in Hogansville was built for Frank Word and his wife Eugenia Pullen on the site of the plantation of her grandfather, William Hogan. Word and his brother did much to develop industry and commerce in Hogansville around the turn of the 20th century. Once a bed and breakfast, the house remains a Main Street landmark. (Holt & Cates Co., Newnan, Georgia.)

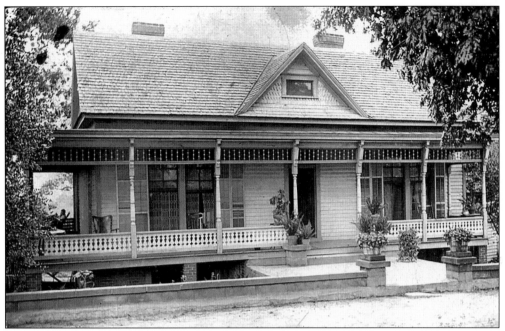

Dr. Robert H. Jenkins, a Hogansville physician, lived in this home on Main Street. The scroll sawn balustrade and spindle frieze give decorative touches to the Victorian cottage. It was razed in 1937 to make way for the Royal Theater, which has served as city hall for Hogansville since 1983.

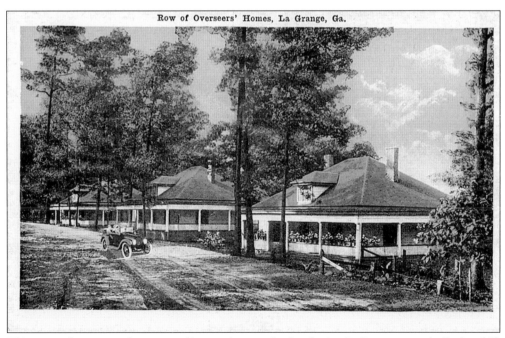

This row of overseers homes on Forrest Avenue in Southwest LaGrange were built for shift supervisors working in Callaway Mills. Without the dirt roads and the 1914–1915 car, one could scarcely tell the difference in the block today. (S.H. Kress & Co.)

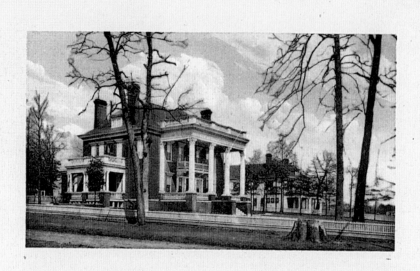

Residence of J. E. Dunson and Judge W. W. Turner, La Grange Ga.

Haralson Bleckley, noted Atlanta architect, designed this Neo-Classical mansion in 1905 for Joseph E. Dunson. Bleckley was the grandson of Gen. Hugh Haralson whose home place once included this site on the corner of Broad and Ben Hill Streets. The Broad Street Church of Christ razed the home in 1963 to build a sanctuary. To the right is the home of Judge W. W. Turner, built in 1908. (Sextochrome. Printed in France.)

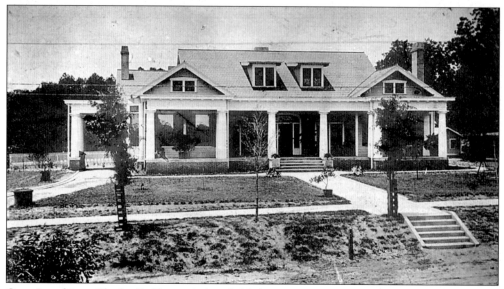

Georgia architect Charles E. Choate designed this house at 1101 Fourth Avenue in West Point for Mr. and Mrs. Will Lanier. Built in 1909–1910, its style is very similar to the one opposite with their Tuscan columns. This one has arched windows and forward projecting bays on each end of the porch. The card is postmarked 1914. (Courtesy of Gary Doster.)

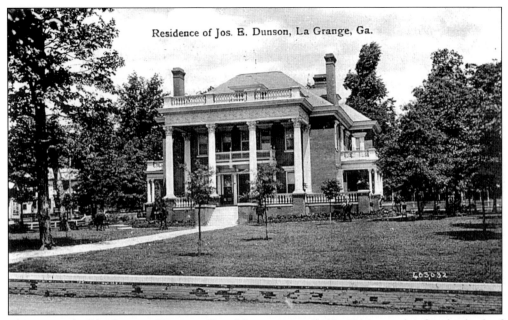

Residence of Jos. E. Dunson, La Grange, Ga.

This postcard of the Dunson House on Broad Street was mailed in 1916, months after the death of its owner, Joe Dunson, who was President of LaGrange Banking & Trust Co., Dunson Brothers, and Dunson Mill. State newspapers lamented the passing of the man they thought would be the next governor of Georgia. (Photographed & Published by J. L. Schaub. Printed in Great Britain.)

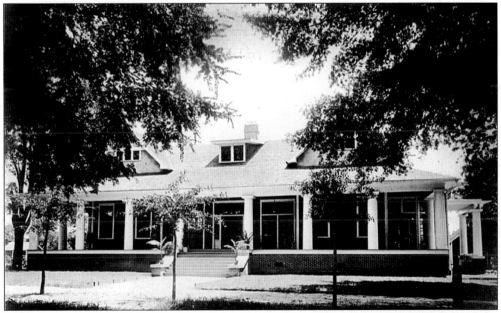

Charles E. Choate designed this house, located at 1200 Second Avenue in West Point, in 1909 for Mr. and Mrs. James Cherry Lanier. McCarthy Funeral Home now occupies the building. The extensive wraparound porch with its Tuscan columns provide an elegant front for the home. The Neo-Classical porch, French windows and doors, and dormers between front-facing gables are typical of Choate. (Courtesy of Ken Thomas.)

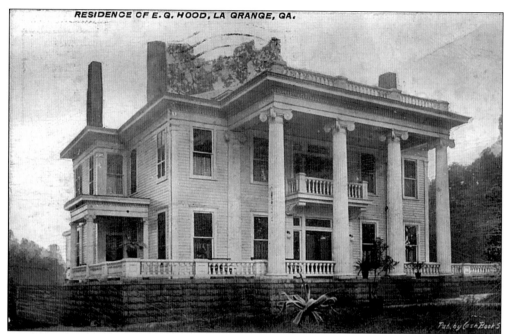

E.D. Roberts erected this Neo-Classical home on Vernon Road across from its Broad Street intersection in 1907 for E.G. Hood. Mrs. Hood was the granddaughter of noted builder Philip Hunter Greene and mother of local poet Carrie Fall Benson. Current owners Bob and Jenny Copeland have maintained this house since 1969, and restored several historic homes, including the John Hill Home in Long Cane. The card is postmarked 1911. (Cash Book Store.)

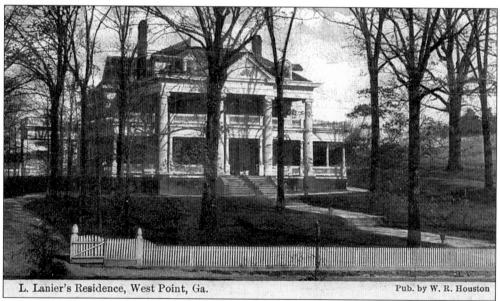

L. Lanier's Residence, West Point, Ga. Pub. by W. R. Houston

After Lafayette Lanier sold his house to W.L. Williams for the Hotel Virent, he had this handsome home built near Fort Tyler, on present-day North Eighteenth Street in Lanett, Alabama, *c.* 1907. The house burned in December 1940, and another home was built on the site by Mr. and Mrs. Bruce Lanier. (Published by W. R. Houston.)

This house at 504 Broad Street was built by W.H. Turner, an executive with Callaway Mills. The Arthur E. Mallory Jr. family lived here from 1955 to 1976. It is now an apartment house. This card served as the Turner family's Christmas greeting card.

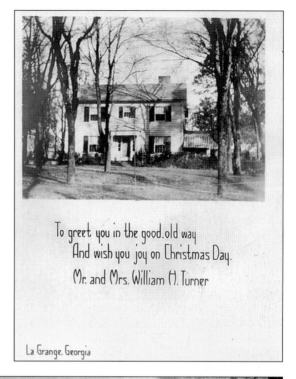

To greet you in the good old way
And wish you joy on Christmas Day.
Mr. and Mrs. William H. Turner

La Grange, Georgia

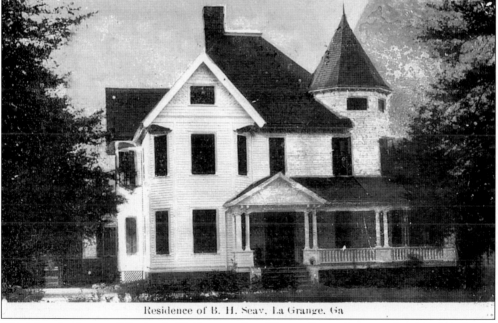

Residence of B. H. Seay, La Grange, Ga

This Victorian home of Benjamin H. Seay stood on Vernon Street. It was replaced in 1934 by the home of Hatton Lovejoy, which has been the LaGrange College President's home since 1965. Seay was a merchant; his wife Ada was a granddaughter of Philip Hunter Greene who built the Oaks across the street. The note on the back reads, "am having such a nice time down here." It was postmarked in 1911 in LaGrange and mailed to Richmond, Virginia.

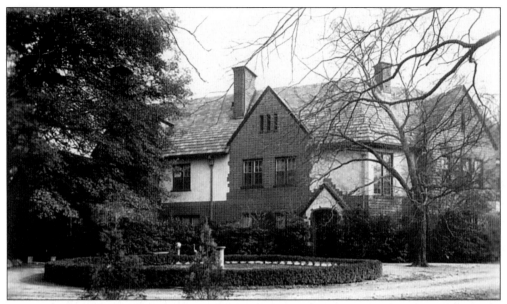

Miss Mary Barnard Nix had P. Thornton Marye design this English manor house in 1926 with money inherited from her uncle John M. Barnard. The Lewis Price family, for whom Price Theater was named, lived in the home for several decades. After years of serving as the School of Nursing for LaGrange College, Sunny Gables has been renovated as the Alumni House for the College.

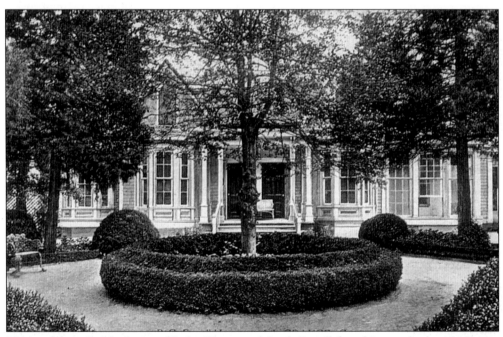

This card featuring the home of Judge Blount and Sarah Ferrell found its way back to LaGrange after having been mailed from Hopkinsville, Kentucky, in 1912 to Lewis County, Missouri. The home, originally a story and a half, double pen, had been given a Victorian facade. The card is postmarked 1912. (Bradfield Drug Co.)

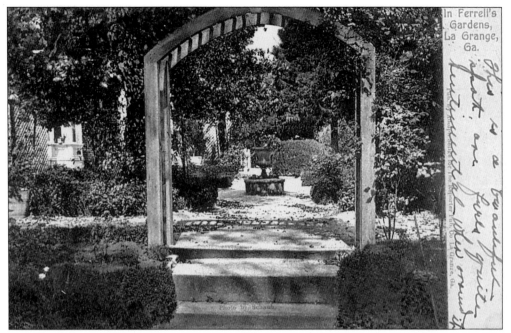

The message on the side of this card reads "This is a beautiful spot, one feels quite sentimental when around it"—an apt description of the Terraces, better known as Ferrell Gardens, long a LaGrange landmark. The Ferrell house can partially be seen on the left behind the arched arbor in this card, postmarked 1907. (Adolph Selige for Reporter Publishing Co. Published in Germany.)

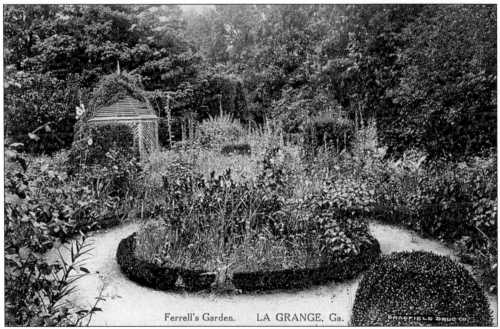

Ferrell's Garden was renowned throughout the South. Nancy Ferrell planted the first portion of the garden in 1832. Her daughter, Sarah Coleman Ferrell, expanded and cared for the garden from 1841 until her death in 1903. (Bradfield Drug Company.)

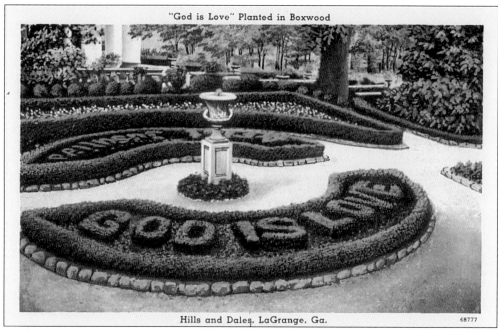

"God is Love" Planted in Boxwood

Hills and Dales, LaGrange, Ga. 68777

"God is love" is one of the boxwood mottoes that Sarah Ferrell planted in her garden. The mottoes and the sheer beauty caused the invading Union Army to spare the gardens when 3,000 troops passed through in 1865. The motto in the other half of the circle reads "Fiat Justicia," Latin for "Let Justice Be Done," a reference to Judge Ferrell's profession. (Tichnor Brothers, Boston.)

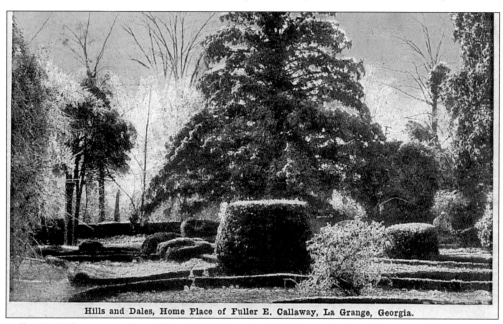

Hills and Dales, Home Place of Fuller E. Callaway, La Grange, Georgia.

Fuller E. Callaway purchased Ferrell Gardens in 1911 from the Ferrell Estate. Three years of neglect since the death of Judge Ferrell left the Callaway's with the monumental task of reclaiming the attraction. This winter scene shows snow on the Cunninghamia Tree, one of many rare specimens that Mrs. Ferrell imported from around the world. (S.H. Kress & Co.)

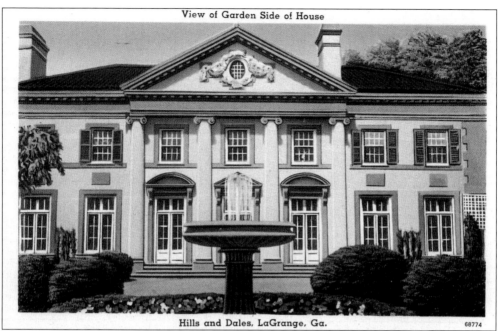

View of Garden Side of House

Hills and Dales, LaGrange, Ga. 68774

Architect Neel Reid, whose family was from LaGrange, designed this Italian villa for Fuller and Ida Callaway. Begun in 1914 and completed in 1916, the villa replaced the Ferrell home while complimenting Mrs. Ferrell's Italian-style gardens. This southern garden-side facade overlooks a beautiful fountain, which the Callaways added. Callaway always described himself as a capitalist but he was also a leading merchant, textile manufacturer, and philanthropist. (Tichnor Brothers, Boston.)

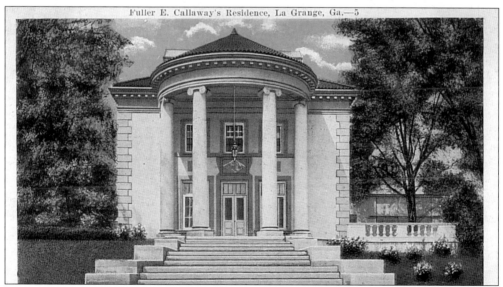

Fuller E. Callaway's Residence, La Grange, Ga.—5

The eastern end of Hills and Dales, the name of the Callaway home, is the first view seen when entering the grounds from LaGrange. In 1936, it became the home of Fuller Callaway Jr. and his wife Alice, who cared for the gardens until her death in 1998. Her heirs donated the property to the Fuller E. Callaway Foundation, which is opening it to the public. (E.C. Kropp, Milwaukee.)

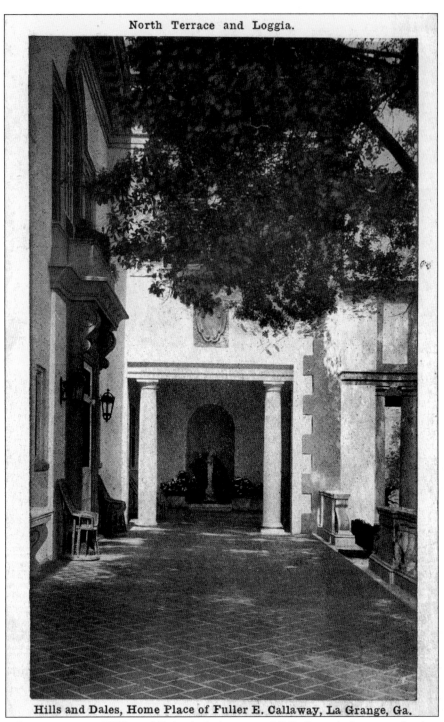

Hills and Dales, Home Place of Fuller E. Callaway, La Grange, Ga.

The northern exposure of Hills and Dales includes a grand Palladian window over the doorway, left, and a covered portico area at the end of the terrace. The Callaway Coat of Arms, copied from stained-glass windows in St. Neots Church in Cornwall, England, is carved in stone above the two Tuscan columns. (S.H. Kress & Co.)

Nine
HERE AND THERE

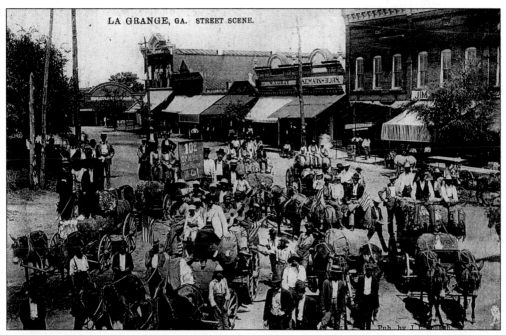

LA GRANGE, GA. STREET SCENE.

Fluctuations in the cotton market sometimes brought protests from growers. The fact that cotton would keep in storage for years allowed growers to threaten "going to the warehouse" unless prices were met. A price of 10¢ a pound was being asked here. Despite the protest, the atmosphere seemed almost festive with guitars and flags. This card appears to be made from an earlier photograph, which dated from the 1890s.

This greeting card, though labeled "LaGrange, GA," was postmarked Gabbettville, Georgia, in 1914 and addressed to Miss Stella Bailey at Long Cane, Georgia. Before Miss Bailey died at the age of 101 in 1993, she had been the oldest-living member of Pleasant Grove Methodist Church, located southeast of LaGrange. (Published in Cincinnati, Ohio.)

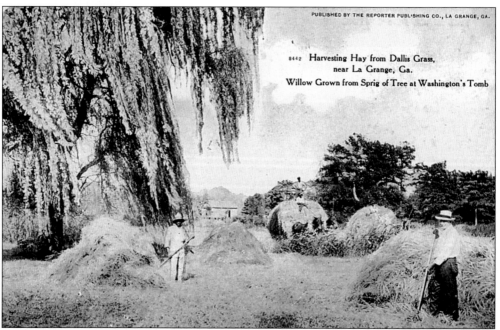

Abner Thomas Dallis of Troup County developed a variety of hay known as Dallis grass that proved to be popular throughout the country. The card attests to the abundant yield of the grass. (Curteich.)

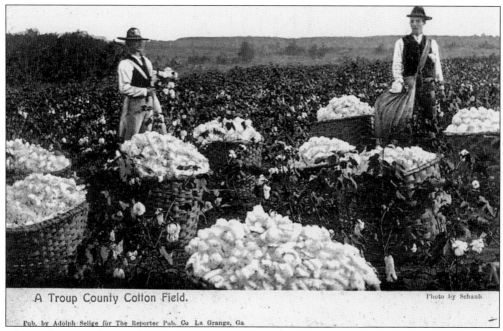

A Troup County Cotton Field.

Photo by Schaub.

Pub. by Adolph Selige for The Reporter Pub. Co La Grange, Ga

This card shows what would have been a common scene in Troup County from the 1840s until the 1940s. Cotton was the staple of the rural economy until the boll weevil arrived and textile manufacturing in town offered employment. (Photo by Schaub. Adolph Selige, Publisher, St. Louis, Missouri, for Reporter Publishing Co. Made in Germany.)

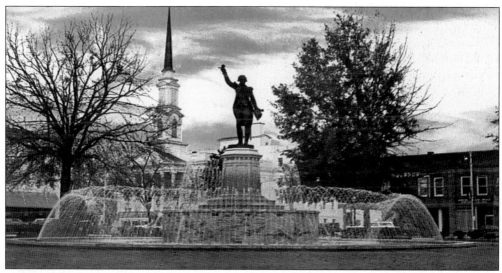

Since 1976 when the statue of the Marquis de LaFayette, who LaGrange's name honors, was placed on the Square, this scene has become perhaps the most photographed place in the county seat. Dr. Waights G. Henry Jr., then President of LaGrange College, spearheaded efforts to obtain this statue that Callaway Foundation, Inc., funded. The City maintains the statue and its park and sponsored a 25th anniversary refurbishing. Rotarians from LaGrange and Lafayette's birthplace in France led citizens of Troup County in a week-long rededication celebration. (Bill Holt, photography. Used with permission.)

INDEX